IMAGES
of America

IRISH
STATEN ISLAND

IMAGES
of America

IRISH
STATEN ISLAND

Margaret Lundrigan

ARCADIA
PUBLISHING

Published by Arcadia Publishing
Charleston SC, Chicago IL, Portsmouth NH, San Francisco CA

Printed in the United States of America

Library of Congress Catalog Card Number: 2008928811

For all general information contact Arcadia Publishing at:
Telephone 843-853-2070
Fax 843-853-0044
E-mail sales@arcadiapublishing.com
For customer service and orders:
Toll-Free 1-888-313-2665

Visit us on the Internet at www.arcadiapublishing.com

This work is dedicated to my brother-in-law, Ted Harris, who is a wonderful Staten Islander and Irish American.

CONTENTS

ACKNOWLEDGMENTS

Many thanks to Robert Connelly and Mimi Cusick, who were extremely generous in sharing historic photographs and personal memories. Most especially, I would like to thank family members Helen Vitaliano, Dot Hurley, and Bill Wolfe for giving generously of their time and for going far beyond to help locate photographs. Most importantly, it was a great pleasure to spend time with them again. I was fortunate to meet Bill Reilly and Donald McAndrews of the Ancient Order of Hibernians and Lynn Rogers of the Friends of Abandoned Cemeteries. They are doing important work in the Irish community on Staten Island. A special thank-you goes to Staten Island historian Marjorie Johnson, who has been a resource for all these volumes and whose contribution to the preservation of Staten Island history is invaluable. As always the Staten Island Historical Society has been a wonderful resource both for its archives and photographs. Since the first book, Carlotta Defillo has been a friend and source of guidance. The assistance of Dorothy Delitto of the Staten Island Institute of Arts and Sciences, who recently passed on, was deeply missed in researching this volume. Special thanks go to photographer Jim Romano, who has captured island and metropolitan events for 60 years, for permission to use a number of beautiful photographs. Also, thanks go to Bill Murphy for allowing the use of his work, which makes an important addition to this book. Thanks go to Bill Higgins for the beautiful John Noble portrait. I would like to thank Judy Dini for wonderful family photographs of Rosebank and South Beach. Thanks go to Sheila Michaud and Ken O'Brien for photographs and for reaching out to friends and family for resources. Merrie, Peggy, and Tom Lindsay gave generously of their time to make contacts and get photographs. Thanks go to friends Pam Furlong, Amy Stern, Mary Ruth, and John Stone and childhood friend Judy Catarella who have given support and encouragement. As always thanks go to family members Brendan, Noreen, and Ted Harris and Connie and Jim Lundrigan. Most especially, I would like to thank my daughter, Meghan Ferrer, who has been an invaluable resource and support with research. Meghan is also my computer expert.

INTRODUCTION

One of the earliest influences of the Irish in Staten Island and New York was the appointment of Thomas Dongan in 1682 as governor of New York. Dongan, a Catholic member of the nobility born in Kildare, Ireland, was appointed by King James. A man of humor and integrity, he is remembered for the creation of the Charter of Liberties, which set forth basic freedoms. He was an early proponent of religious freedom. Dongan had great land holdings on Staten Island and owned a lodge there. In 1687, a grant of 5,000 acres known as "the Lordshippe or manner of Cassiltowne" was made to Governor Dongan. Dongan's influence is still present in area names such as Dongan Hills and Castleton Corners. The influence of the Irish on Staten Island is evident from Colonial time up until the present. While Dongan was Catholic, the Irish who came during the Colonial period tended to be mainly Protestants from Ulster. As the colonies moved toward freedom, Ulster Irishman Richard Conner would serve in the First Provincial Congress held in New York on May 22, 1775.

Throughout the 19th century up until the 1990s, New York City was recognized as having the largest population of Irish heritage of any American city. From the years of the 1840s onward, there was a tremendous influx of the Irish to America. Many of the contributions of this community, both in Staten Island and New York City, were made by the working class. Unlike many other groups who emigrated as family groups, the Irish often came as single persons. During the apex of emigration following the Great Famine of 1854, this group swelled to fill the ranks of domestic servants and manual laborers. Many of the young women who came served in the homes of the wealthy as cooks, maids, and nannies. Many young men worked as "groundhogs" in the excavation of the tunnels that would connect Manhattan to New Jersey. Later many Irish immigrants would fill the ranks of civil servants as police, firefighters, and teachers. Finally, as these immigrants secured their place in American society, they left their mark in every area of life in New York and Staten Island.

The Irish presence on Staten Island is reflected in such diverse areas as the political, the geographic, and the academic. Reminders of the Irish are seen in early place names on Staten Island such as Tipperary Corners, Young Ireland, and New Dublin. A number of schools and churches, such as St. Patrick's and Monsignor Farrell High School, recognize both Irish culture and the contributions of the Irish in establishing schools and churches. Fr. John Drumgoole founded Mount Loretto to provide care for homeless children. Mount Loretto would ultimately provide homes and schooling for thousands of needy children. The Fenian Irish leader Jeremiah Rossa O'Donovan would spend the last years of his life as an exile on Staten Island. Bank robber Willie Sutton would elude capture as he worked quietly at Sea View Hospital under the alias

Eddie Lynch. Irish culture even touched Staten Island folklore in the legend of "David and the Cow Frog." The 200-pound Irish cow frog was said to have lived in Britton's Pond for two years before being returned to Ireland on a ship bound for Tipperary. Terry Crowley would achieve fame in the world of baseball and play in three World Series.

The Irish have been actively represented in political life with several borough presidents of Irish ancestry, including borough presidents John Lynch and Robert T. Connor along with longtime political figure Congressman John M. Murphy. Assemblywoman Elizabeth Connelly's remarkable 27-year career left a historic legacy in many areas and encompassed the treatment of persons with psychiatric disabilities, cognitive impairment, or substance abuse issues. The Irish continue to be a vibrant part of the Staten Island community in every phase of its diverse life.

One

THE DISTANT PAST

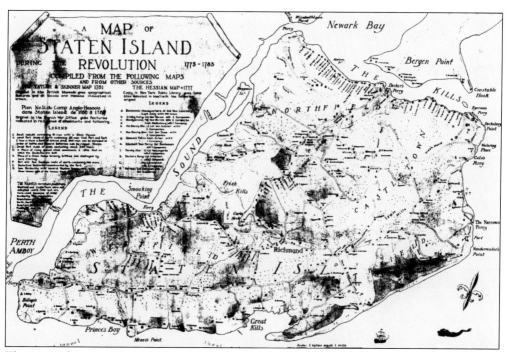

This map of Staten Island during the Revolution was compiled by Loring McMillen. The area known as Castletown shows the influence of Gov. Thomas Dongan, governor of New York from 1682 to 1688. Dongan, an Irish Catholic born in Kildare, Ireland, called the colony's first representative assembly and issued the Charter of Liberties. Cassiltowne was the name given to land granted to Dongan on Staten Island. The governor also had a manor on Staten Island. Dongan's influence remains on the island in place names such as Castleton Corners and Dongan Hills. The later "Old Place Map" by Charles W. Leng and William T. Davis shows the names of Young Ireland, Tipperary Corners, and New Dublin in Egbertville, indicating the Irish presence there. (Courtesy of Staten Island Historical Society.)

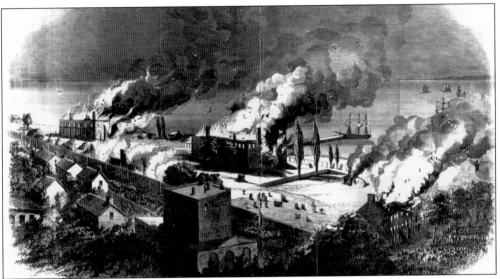

This image is from Frank Leslie's illustrated newspaper, September 18, 1858. The 1840s and 1850s brought many Irish immigrants to America who were fleeing the Great Famine. Many of these immigrants arrived sick with yellow fever and typhus and were treated at the quarantine hospital in Tompkinsville. On September 1, 1858, the hospital was the scene of a protest that resulted in the hospital being burned to the ground. The protest was the culmination of years of resentment regarding the treatment of immigrants with contagious diseases at the hospital. (Courtesy of the Staten Island Historical Society.)

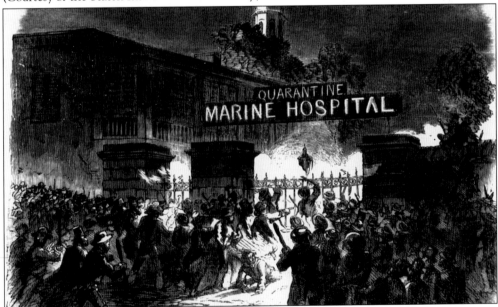

Until it was destroyed by protestors in 1858, the Quarantine Marine Hospital treated as many as many 9,000 immigrants annually. As many 1,500 may have died each year; an overwhelming number were Irish immigrants seeking a better life. The Emerald in 1851 reported on the plight of families with loved ones being treated at the hospital. Without jobs or support, they would go to the police station where they were given food. (Courtesy of the Staten Island Historical Society.)

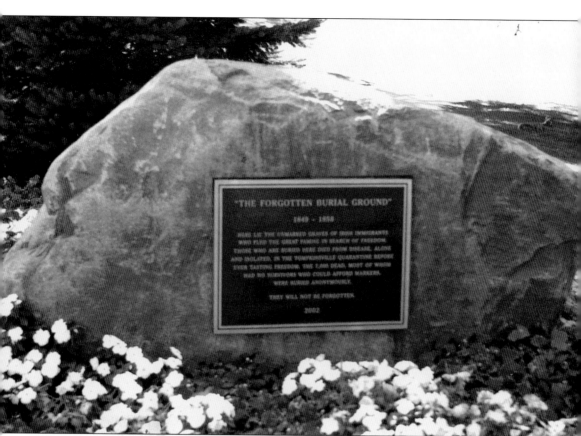

This plaque is embedded in a boulder close to the Silver Lake Golf Course clubhouse, and the 18th hole commemorates the many Irish immigrants who are believed to be buried here. High school student Caitlin Tormey spent four years researching the site and was instrumental in establishing support for the monument. Researcher Stephanie Schmidt believes this to be the location of the Marine Cemetery that was in operation from 1849 to 1858. The plaque reads, "'The Forgotten Burial Ground' Here lies the unmarked graves of Irish immigrants who fled the famine in search of freedom. . . . They will not be forgotten." (Author's collection.)

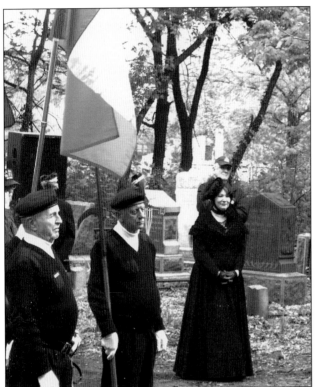

This photograph shows T. J. McSorley with Lynn Rogers at a 2006 fund-raiser for Friends of Abandoned Cemeteries. Bill Reilly, past president of the Ancient Order of Hibernians, and Lynn Rogers, Friends of Abandoned Cemeteries, joined together to advocate for proper burial of those buried in a mass grave on the site of the municipal parking lot in St. George. Both Reilly and Rogers believe they may have relatives buried at the site. The lot is the planned site of the new courthouse complex. Reilly and Rogers received thousands of letters from as far as Australia in support of their efforts. Present plans will place a 20-foot-by-20-foot area at the site in remembrance of those who died. (Courtesy of Lynn Rogers.)

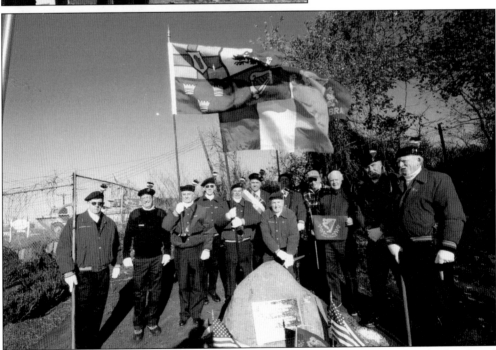

The Ancient Order of Hibernians, Division 4, has joined with the Friends of Abandoned Cemeteries to adopt 12 grave sites of Irish soldiers who fought in the Civil War. The group also places American and Irish flags at the grave sites. (Courtesy of Donald McAndrews.)

Two

POLITICAL LIFE

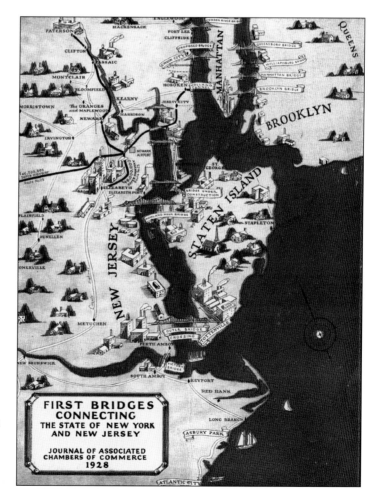

This chamber of commerce map from 1928 shows Staten Island before it was connected by any major bridges. Borough Pres. John Lynch was instrumental in the realization of the three bridges to New Jersey. (Author's collection.)

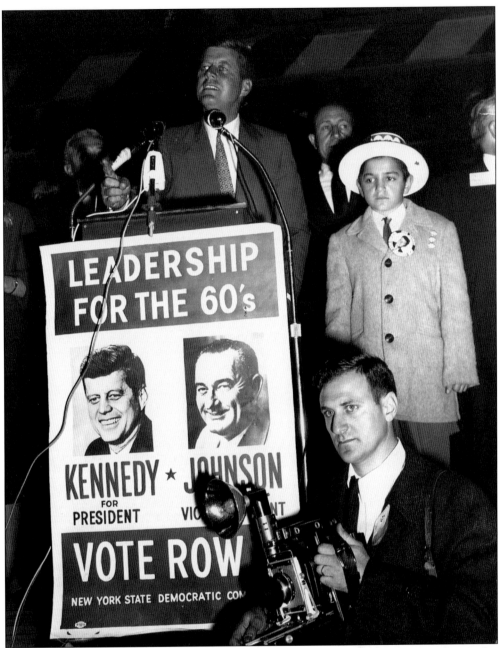

During this campaign visit, Sen. John F. Kennedy stopped at Lambetti Hall. Kennedy gave his support to democratic hopefuls John Murphy, Ralph Diorio, Phillip Massa, and Elaine Kovessy. Seen in the foreground is Staten Island photographer Jim Romano. Romano has covered virtually every historic event on Staten Island for the past 60 years. (Courtesy of Jim Romano.)

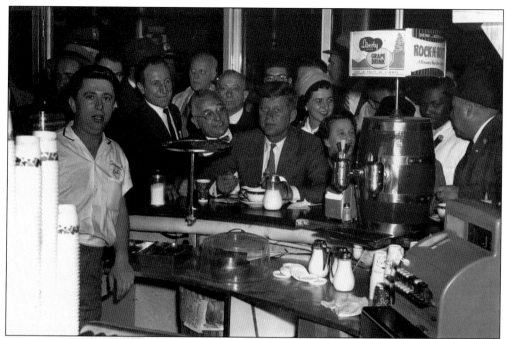

On October 27, 1960, John F. Kennedy visited Staten Island during the presidential campaign. Kennedy would, of course, go on to become president and the only Irish Catholic to do so. Kennedy traveled to the island aboard the ferryboat *Cornelius Kolff*. The candidate spoke to a crowd of about 15,000 and gave his apologies "to any Republican commuters who were unwittingly caught in the crowd." (Courtesy of Jim Romano.)

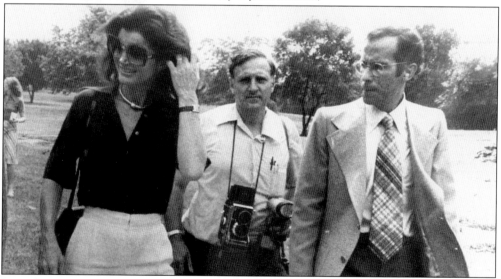

Jacqueline Kennedy Onassis is photographed with Barnett Shepherd (right), director of Snug Harbor Cultural Center. Onassis, director of the Municipal Art Society and an advocate of historic preservation, came to Snug Harbor to give support to the cultural center. Although usually remembered for her French heritage on the Bouvier side, Onassis also shared an Irish heritage. Her great-great-grandparents on her mother's side were Thomas and Frances Lee. The Lees were born in County Cork and immigrated to Newark, New Jersey. (Courtesy of Jim Romano.)

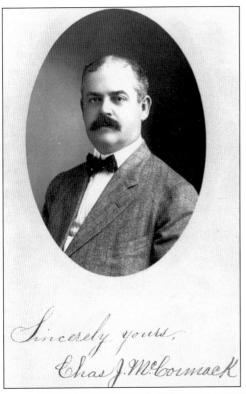

Sincerely yours,
Chas. J. McCormack

Borough Pres. Charles J. McCormack was born in Manhattan in 1865 to Irish parents and spent his early years in Manhattan. McCormack moved to Staten Island in 1895 and settled in Rossville. He was elected to the assembly in 1902 as the Democratic candidate. In 1913, he ran successfully against George Cromwell. McCormack became ill during his term and died on July 11, 1915. During his time in office, McCormack oversaw road and sewer projects and worked to eliminate industrial pollution. McCormack was also concerned about the plight of unemployed workers. (Courtesy of the Staten Island Historical Society.)

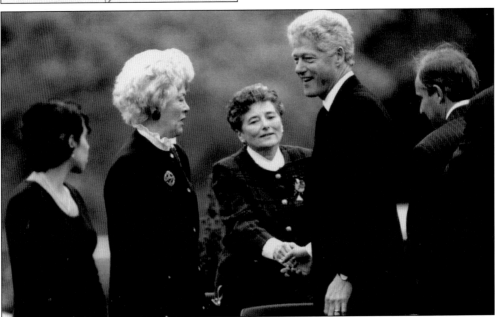

Pres. Bill Clinton, seen with Elizabeth Connelly (second from left), came to the island in support of the candidacy of assemblyman Eric Vitaliano in his race against Susan Molinari. President Clinton shares Irish ancestry through his mother, who was a Cassidy. While John F. Kennedy was the only practicing Catholic to attain the office of president, 23 U.S. presidents have some traces of Irish lineage. (Courtesy of Jim Romano.)

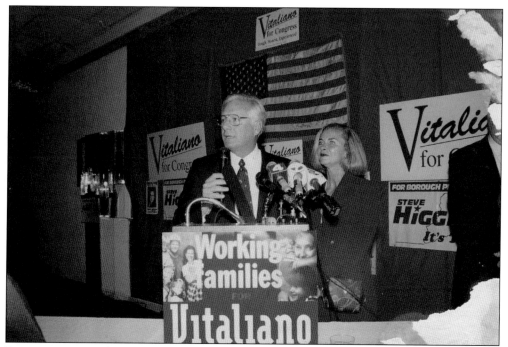

Former city councilman Jerome O'Donovan and his wife are pictured campaigning for Eric Vitaliano, who has been a well-known political figure on Staten Island. In 2001, O'Donovan was chosen to be the grand marshal of the Staten Island St. Patrick's Day parade. A movement to boycott the parade was initiated because of O'Donovan's pro-choice political views. (Courtesy of Robert Connelly.)

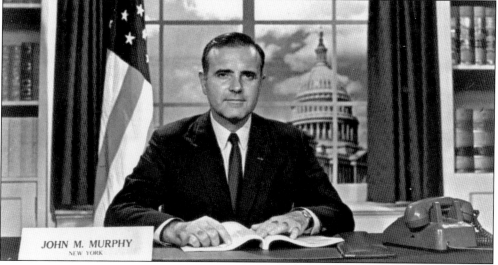

Congressman John Murphy was born on August 3, 1926. Murphy would be a congressman from 1963 to 1981. Before his congressional career, he graduated from West Point and served in the military from 1944 to 1956. A Korean War hero, Murphy received the Silver Star for his service during the Korean War. The congressman was extremely popular and involved in many community civic affairs during the 1960s and 1970s. (Courtesy of the Staten Island Historical Society.)

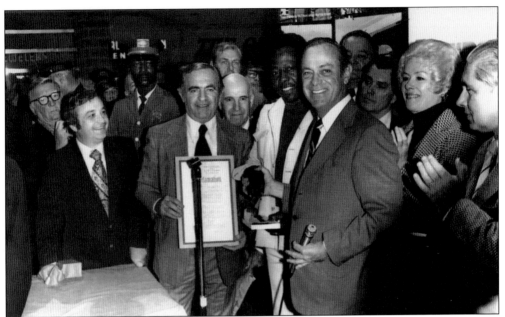

Borough Pres. Robert T. Connor, the 11th borough president of Staten Island, held the office of borough president from 1966 to 1977. Connor initially ran on the Democratic ticket, but he changed to Republican in his second term. Connor was an ardent opponent of secession. He resigned in 1977 to accept a civilian naval position in the Carter administration. Borough Pres. Robert T. Conner (holding the microphone) is photographed with Hank Aaron (second row, second from left), Sen. John Marchi (far right), and Elizabeth Connelly (second from right). (Courtesy of the Connelly family.)

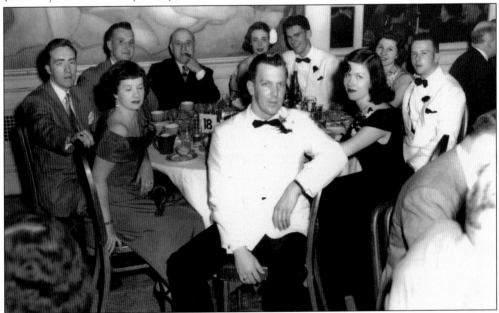

This early photograph shows Robert and Elizabeth Connelly attending a political dinner. Robert is seated in the center and is wearing a white dinner jacket. Elizabeth is to the right wearing a dark gown. (Courtesy of Robert Connelly.)

Borough Pres. John "Jack" Lynch was born in 1882 and grew up on Caroline Street and later Delafield Avenue in West New Brighton. His family was active in the building trades on Staten Island. He was elected as state senator in 1918 and sponsored legislation for the building of the Goethals Bridge and Outerbridge Crossing. Upon the death of Borough Pres. Matthew Cahill, he completed the remainder of his unfinished term. He was then reelected. Lynch would later lose elections. (Courtesy of the Staten Island Historical Society.)

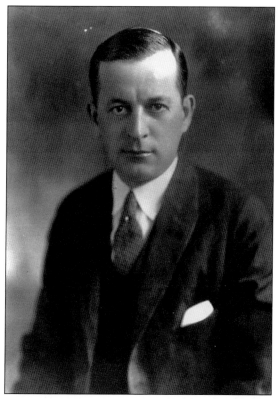

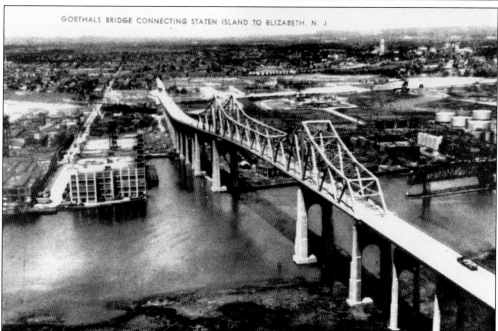

Pictured here is the Goethals Bridge. As a senator, John Lynch sponsored legislation for both the Goethals and the Outerbridge Crossing. It was during his time in office that three major bridges opened. (Courtesy of Randall Gabrielan.)

Assemblywoman Elizabeth Connelly served in the legislature for 27 years. She was born as Elizabeth Keresey in 1930 in Brooklyn. Elizabeth met her husband, Robert, while working for Pan American. The couple moved to Graniteville in 1954 and raised four children. Elizabeth entered public office in 1973. She described herself as a "conservative Democrat" and became the first woman in New York history to hold the position of assembly speaker pro tempore. She died in 2006 from cancer at the age of 77. (Courtesy of Robert Connelly.)

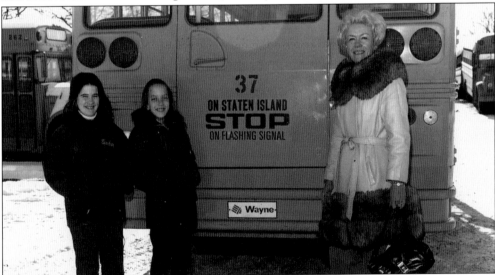

Assemblywoman Elizabeth Connelly poses with her daughter, Terri (center), and another girl in front of a school bus following passage of the bill she sponsored requiring vehicles to stop for school buses. The other boroughs later followed and enacted legislation requiring vehicles to stop for the buses. (Courtesy of Robert Connelly.)

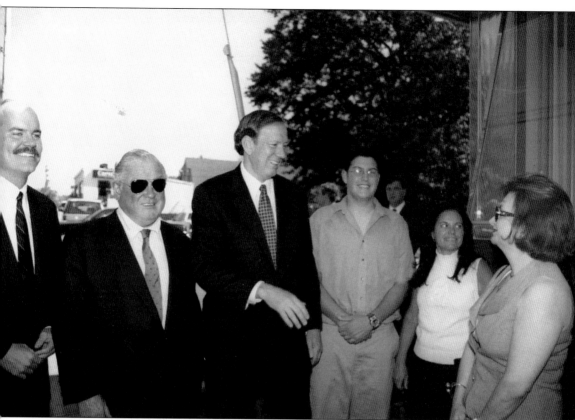

In 2005, Gov. George Pataki (third from left) appointed Francis H. Powers (second from left) to the Metropolitan Transit Authority. The governor is seen here with Powers and his wife, Diane (far right). In 2008, Francis H. Powers, known as Frank, was nominated by the Staten Island and Brooklyn Republican Party as the Republican candidate for New York's 13th Congressional District. Both Francis H. and Diane Powers have been involved in many community and charitable endeavors on Staten Island. On June 22, 2008, Francis H. Powers passed away suddenly. (Courtesy of Jim Romano.)

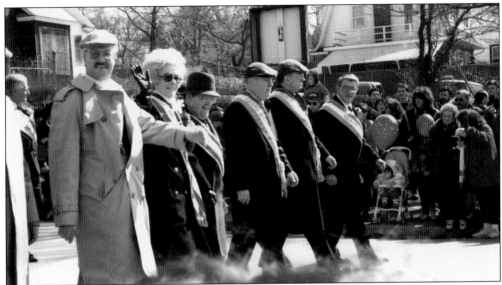

Past grand marshals are photographed marching together in the 1993 Staten Island St. Patrick's Day parade. From left to right, they are district attorney Bill Murphy, assemblywoman Elizabeth Connelly, public administrator John D. Kearney, board of education member James F. Regan, Msgr. Peter Finn, and Ray Taylor, past president of the Ancient Order of Hibernians. (Courtesy of Mimi Cusick.)

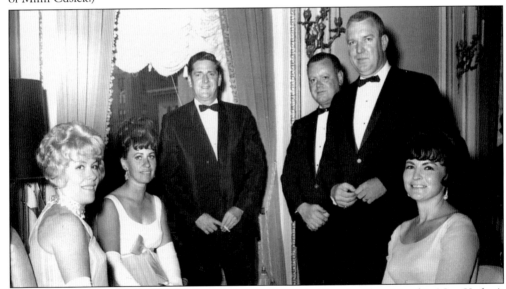

The Connellys are photographed at an Air France dinner held at the Plaza Hotel in New York. A lifelong Staten Islander, Robert Connelly (standing, right), whose first job was as a grave digger in St. Peter's Cemetery, had a long and successful career in the transportation industry. Beginning with Pan Am and going on to his own company, Henje, Inc., Robert made innovation in the transportation of day-old baby chicks. He left the business to help Elizabeth (left). He continues to be active on the boards of numerous community agencies, including Mount Loretto, Catholic Youth Organization, and Mount Manresa. Throughout her 27-year career in the assembly, Elizabeth advocated tirelessly for the need of the cognitively impaired, mentally ill persons with addictions, and the elderly. (Courtesy of Robert Connelly.)

Seen in this 1993 St. Patrick's Day parade photograph, from left to right, are Msgr. Peter Finn, Judge Peter P. Cusick, and assemblywoman Elizabeth Connelly. Msgr. Peter Finn was born in Stapleton and has served the church and community in a variety of roles, including pastor, teacher of social studies at Farrell High School, seminary rector, and district superintendent of schools. He is co-vicar of the island with Msgr. James Dorney and has recently returned to Staten Island as pastor of Blessed Sacrament Church. The monsignor was honored for his many contributions at a dinner at St. Joseph's Seminary in September 2008. (Courtesy of Mimi Cusick.)

Assemblyman Michael J. Cusick and Wexford mayor George Lawler pose for a photograph in Albany on March 10, 2008, while attending the Irish legislators' dinner. (Collection of Mimi Cusick.)

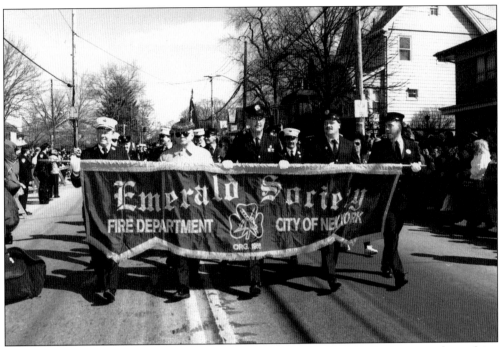

Members of the Emerald Society of the New York City Fire Department are pictured marching in the Staten Island parade. The New York Emerald Society was founded in 1953. (Collection of Mimi Cusick.)

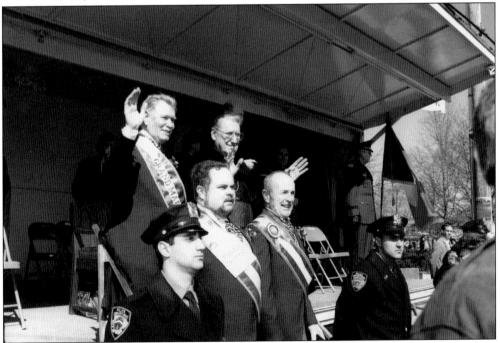

Supreme Court justice Peter P. Cusick (top left), grand marshal of the 1993 Staten Island St. Patrick's Day parade, and John Cardinal O'Connor (top right) wave from the reviewing stand. (Courtesy of Mimi Cusick.)

Justice Peter P. Cusick poses with his son, Michael J. Cusick, now New York State assemblyman from the 63rd assembly district. (Courtesy of Mimi Cusick.)

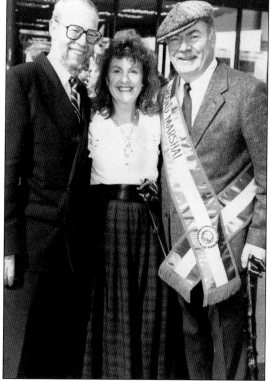

Councilwoman Mary Codd and New York City Board of Education member James Regan (on the right) are photographed for the 1990 St. Patrick's Day parade. Codd was a New York City councilwoman from Staten Island in the 1970s and 1980s. Codd ran as the Liberal Party candidate for mayor in 1981 against Ed Koch and the assembly in 1988. The mother of young children, Codd helped open doors for women in politics. (Courtesy of Mimi Cusick.)

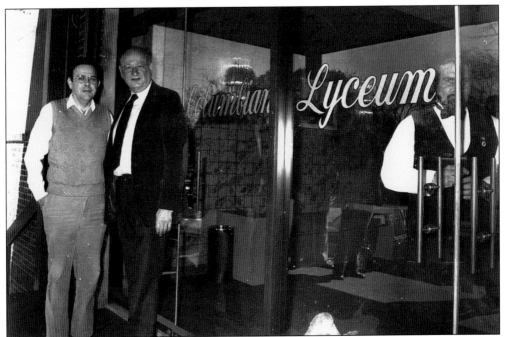

This photograph shows Mayor Ed Koch (right) with Jim Smith on April 10, 1988. Smith was the banquet manager of the Columbian Lyceum in the 1980s. There were frequent celebrity guests such as Mayor Koch at the lyceum. Sen. John Glenn visited the lyceum when he considered running for president. (Photograph by Tony Carannate; courtesy of Jim Smith.)

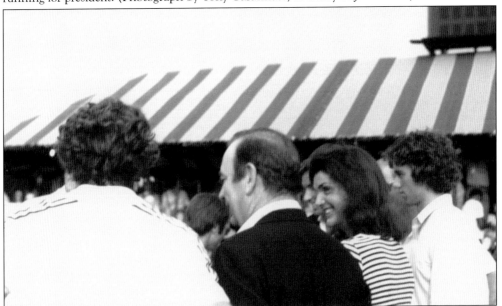

Jacqueline Kennedy Onassis is seen with Gov. Hugh Carey (second from left) at the Robert F. Kennedy Memorial Tennis Tournament in Queens. Jim Smith was president of the Young Democrats of Richmond County during in the 1970s. The group would frequently attend the tournament, which was a magnet for celebrities. Smith's hobby is photography, and he took this shot of Kennedy with the governor. (Courtesy of Jim Smith.)

Cornelius (Con) Fitzpatrick and Alice Donovan are seen in this photograph prior to their marriage in 1947. Donovan was born in Bulls Head. Both she and Fitzpatrick were active in the North Shore Democrats. Fitzpatrick was sexton of Blessed Sacrament Church. Elizabeth Connelly later took on the position of secretary that Donovan held on the North Shore Democratic Association. (Courtesy of Mary Fitzpatrick.)

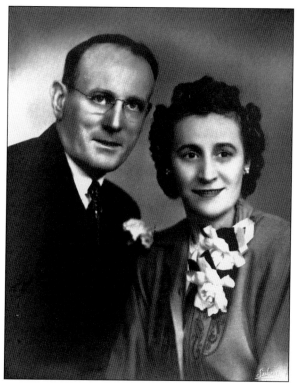

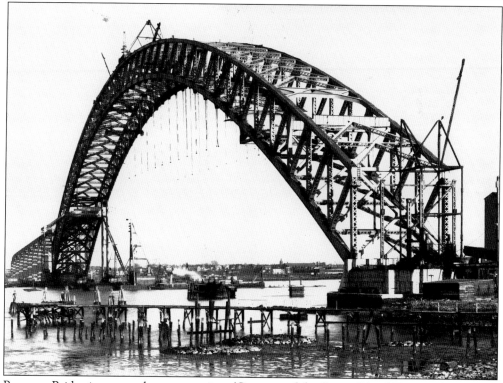

Bayonne Bridge is seen under construction. (Courtesy of the Staten Island Historical Society.)

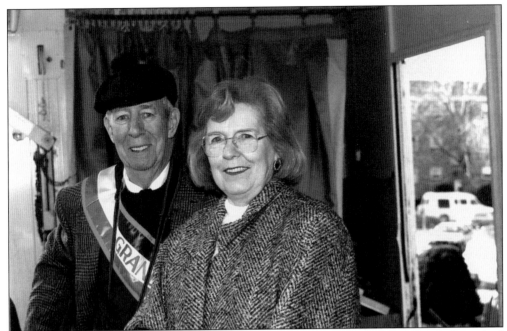

Appellate court justice Tom Sullivan and his wife, Rita, are pictured here. Judge Sullivan had been a past grand marshal of the parade. Judge Sullivan's father was the former district attorney Jeremiah Sullivan. (Courtesy of Mimi Cusick.)

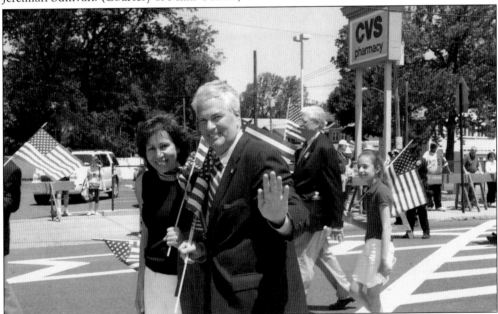

Pictured here are Mike McMahon and his wife, Judy. Councilman McMahon is presently running for Congress. He was elected in 2001 and has won two successive elections for city council. He has advocated strongly on environmental issues such as keeping the Staten Island landfill closed. Prior to becoming a council member, McMahon was an aide to former assemblyman Eric Vitaliano, now a federal justice for the southern district, councilman Jerome X. O'Donovan, and assembly member Elizabeth Connelly. (Courtesy of Jim Romano.)

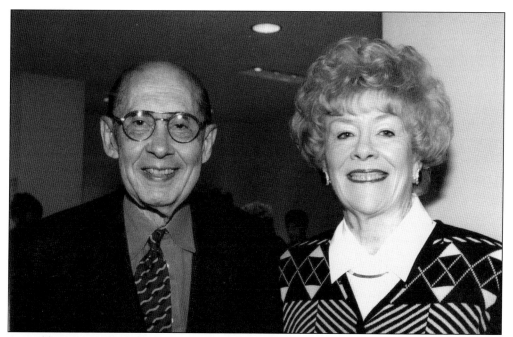

Assemblywoman Elizabeth Connelly is photographed with Sen. John Marchi. (Courtesy of Robert Connelly.)

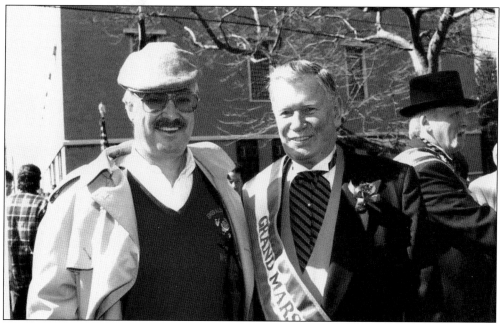

District attorney Bill Murphy poses with grand marshal Justice Peter P. Cusick. The district attorney was a previous grand marshal. (Courtesy of Mimi Cusick.)

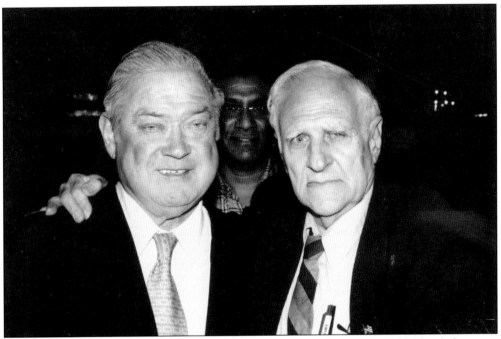

The death of Francis H. Powers (left), pictured here on June 22, 2008, was felt deeply by many Staten Islanders. Powers had achieved great success in both finance and politics. Powers is seen with photographer Jim Romano (right), whose photographic lens has captured metropolitan and Staten Island events for 60 years. (Courtesy of Jim Romano.)

In 1990, public administrator John Kearney served as the grand marshal of the St. Patrick's Day parade. (Courtesy of Mimi Cusick.)

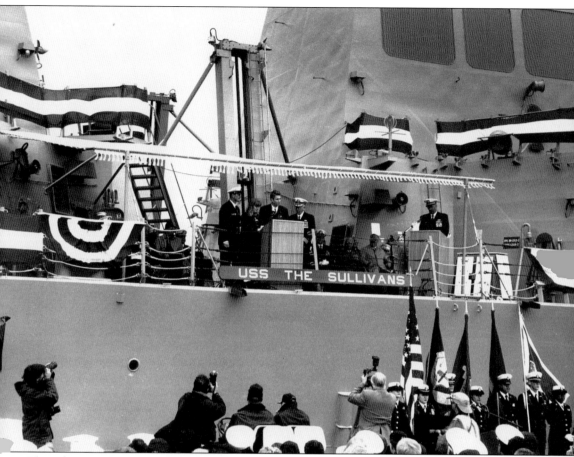

This photograph shows the dedication of the USS *The Sullivans*. On November 13, 1942, the five Sullivan brothers died when their ship *Juneau* was sunk. The Sullivan brothers were posthumously awarded the Medal of Honor. The death of the brothers resulted in a navy policy that discouraged family members from serving on the same ship. (Courtesy of Jim Romano.)

Elizabeth Connelly is photographed at a charity baseball game of Staten Island celebrities in 1982. The game was a benefit for the American Cancer Society, and Connelly served as the first-base coach. (Courtesy of Robert Connelly.)

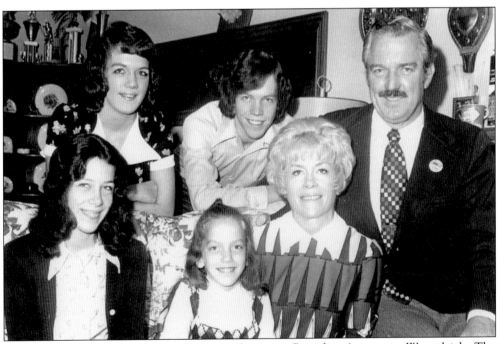

The Connelly family is photographed at its home on Benedict Avenue in Westerleigh. The street was later renamed Elizabeth Connelly Way. From left to right are (first row) Margaret, Terri, and Elizabeth; (second row) Alice, Butch, and Robert. (Courtesy of Robert Connelly.)

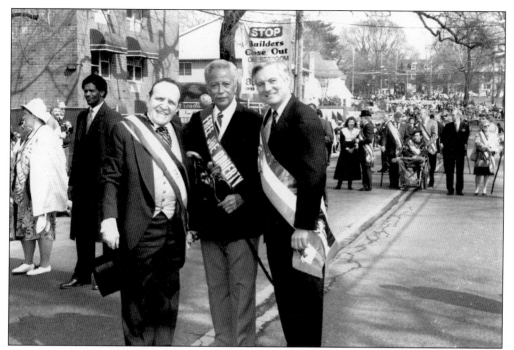

Grand marshal John Kearney, Mayor David Dinkins, and councilman Jerome O'Donovan pose for a photograph at the 1990 Staten Island St. Patrick's Day parade. Mayor Dinkins is wearing a sash that says, "Free Joe Doherty." (Courtesy of Mimi Cusick.)

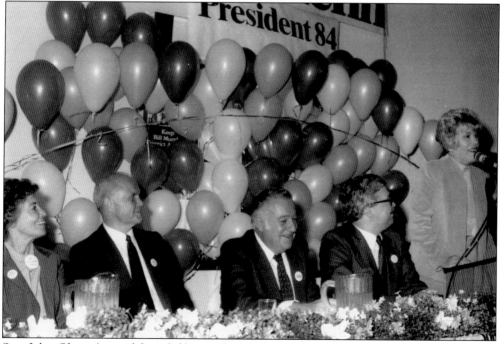

Sen. John Glenn (second from left) attends a dinner at the Columbian Lyceum in 1984 when he considered running for the presidency. Elizabeth Connelly is at the podium. (Courtesy of Robert Connelly.)

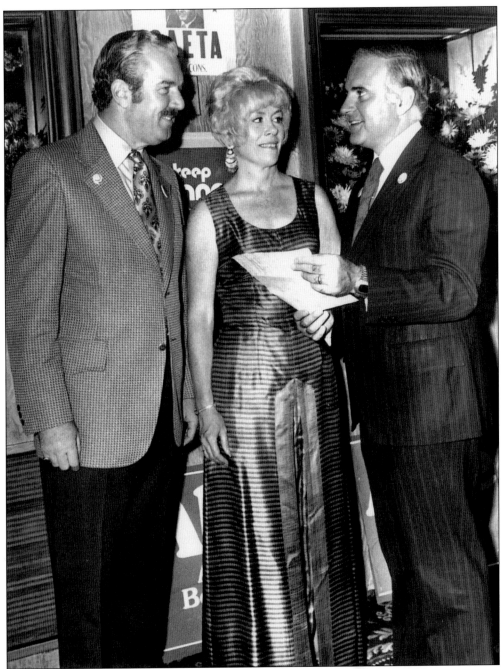

Congressman John Murphy is pictured with the Connellys. Congressman Murphy was convicted in the Abscam scandals of 1980. The congressman's conviction remained controversial, with popular feeling on the island that the conviction was unfair. (Courtesy of Robert Connelly.)

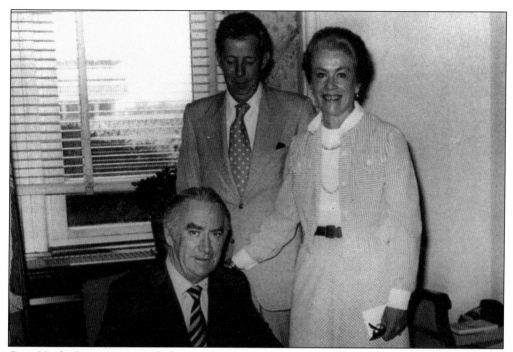

Gov. Hugh Carey poses with former district attorney Tom Sullivan and Elizabeth Connelly. Governor Carey shared Connelly's commitment to the developmentally disabled. The governor signed the consent decree that mandated the closing of Willowbrook State School. (Courtesy of Robert Connelly.)

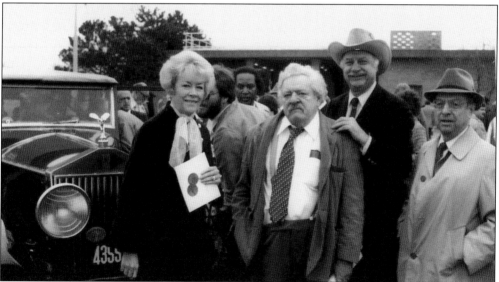

Pictured here is the celebration of the 50th anniversary of the Bayonne Bridge. From left to right, Connelly is pictured with, maritime artist John Noble; Jack Demyan, owner of the Hofbrau and a Staten Island personality; and Mr. O'Donnell, from the Victory Van Lines. Noble, a nationally known maritime artist and popular Staten Island figure, had a Staten Island ferry named in his honor. Demyan was active in many community and civic affairs. Demyan also painted, and Noble referred to him affectionately as "Grandpa Moses." (Courtesy of Robert Connelly.)

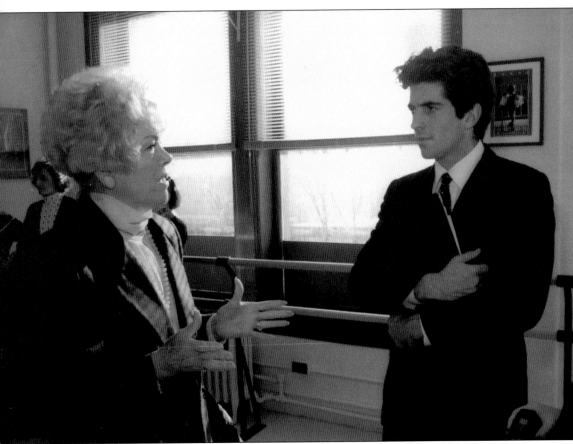

This 1980s photograph shows John Kennedy Jr. speaking with Elizabeth Connelly at the Rome Developmental Center. The Kennedy family and Connelly shared a deep commitment to the interest of individuals with developmental disabilities. (Courtesy of Robert Connelly.)

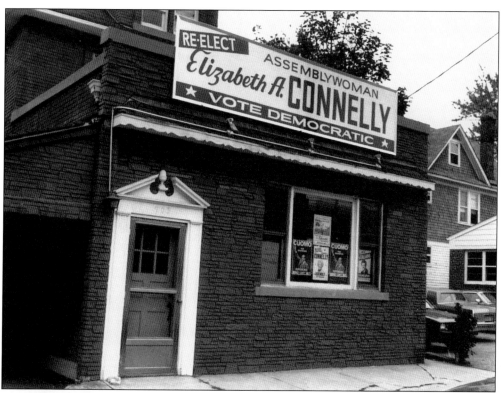

This photograph shows Elizabeth Connelly's 1982 Forest Avenue campaign headquarters. (Courtesy of Robert Connelly.)

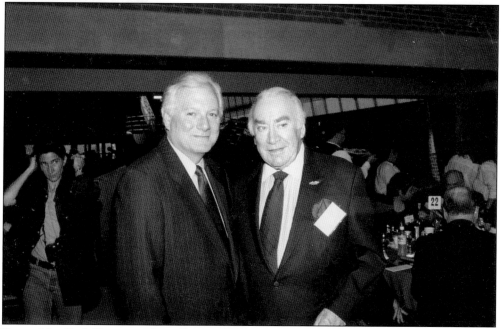

Former New York City councilman Jerome O'Donovan poses with Gov. Hugh Carey. Councilman O'Donovan had a role in the Al Pacino film *City Hall*. (Courtesy of Jim Romano.)

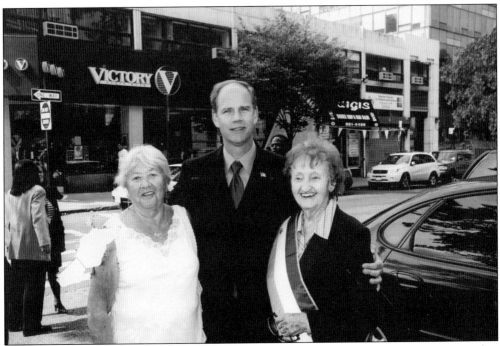

Daniel M. Donovan has been district attorney for Richmond County since 2002. He served as Borough Pres. Guy V. Molinari's chief of staff for six years. (Courtesy of Jim Romano.)

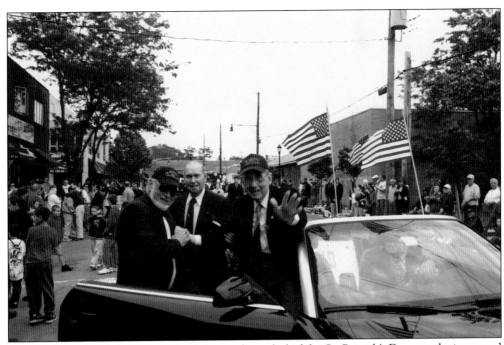

Wearing hats, Sen. John Marchi (right), grand marshal of the St. Patrick's Day parade, is greeted by Tim Rice (left) as he emerges from the car. (Courtesy of Jim Romano.)

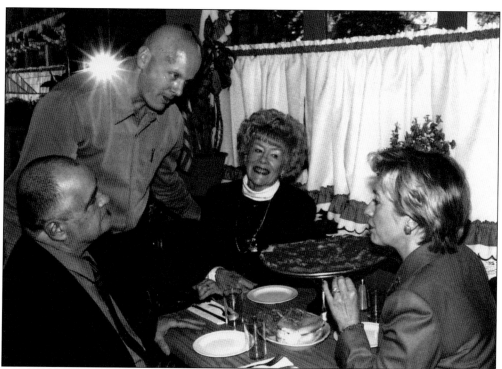

Sen. Hillary Clinton shares a pizza with Elizabeth Connelly. (Courtesy of Robert Connelly.)

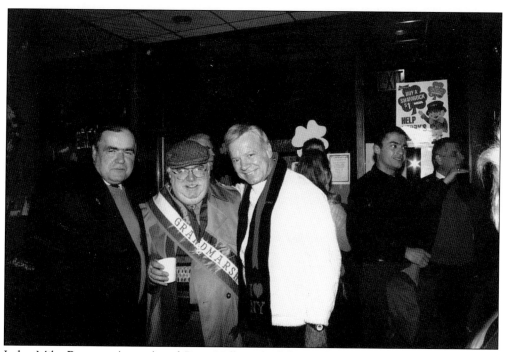

Judge Mike Brennan (center) and Peter Vallone (right) pose for this photograph. (Courtesy of Jim Romano.)

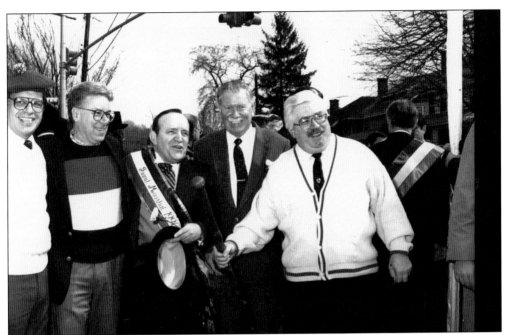

From left to right, family court judge Carmine Cognetta, Supreme Court judge Charles Kuffner, grand marshal John D. Kearney, Supreme Court judge Peter Cusick, and criminal court judge Mike Brennan pose at the 1990 Staten Island St. Patrick's Day parade. (Courtesy of Mimi Cusick.)

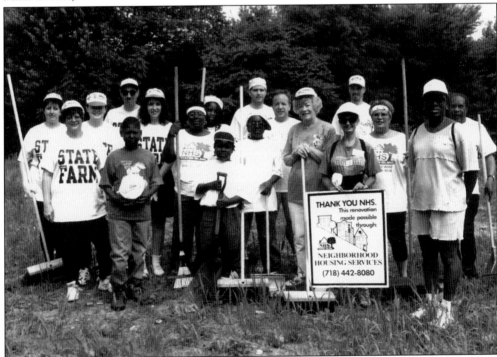

Elizabeth Connelly is photographed with the Neighborhood Housing Services. (Courtesy of Robert Connelly.)

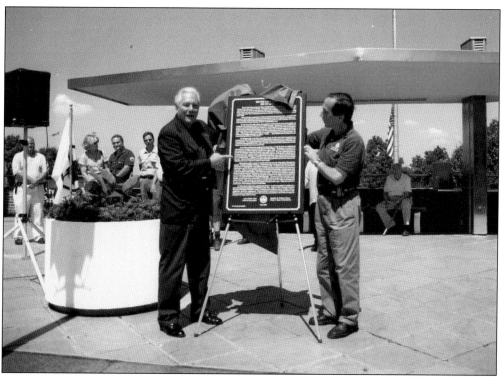

Jerome O'Donovan (left) unveils the Silver Lake plaque. (Courtesy of Jim Romano.)

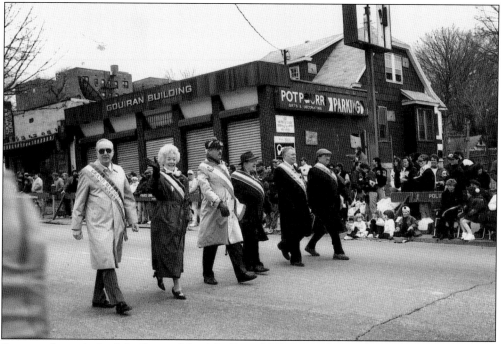

Past grand marshals of the Staten Island St. Patrick's Day parade march together. Pictured here, from left to right, are Robert Connelly, Elizabeth Connelly, Bill Murphy, John Kearney, Peter Cusick, and Msgr. Peter Finn. (Courtesy of Robert Connelly.)

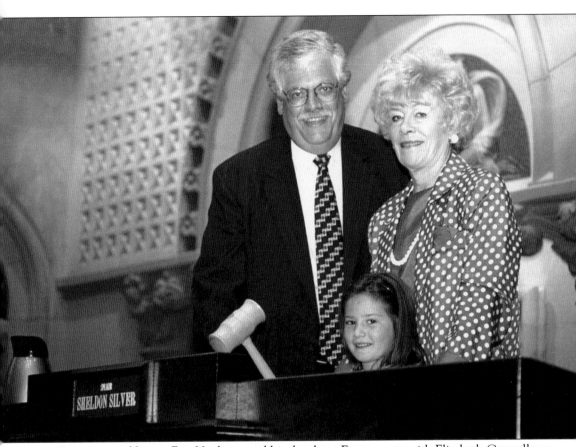

Former assemblyman Eric Vitaliano and his daughter, Emma, pose with Elizabeth Connelly on June 23, 1999. In 2000, after 27 years in the legislature, Connelly decided not to seek reelection. Vitaliano, now a federal judge, called Connelly "the voice in New York that speaks with the greatest compassion and authority for a class of people who are in dire need of a champion." (Courtesy of Robert Connelly.)

Three

CHURCHES AND SCHOOLS

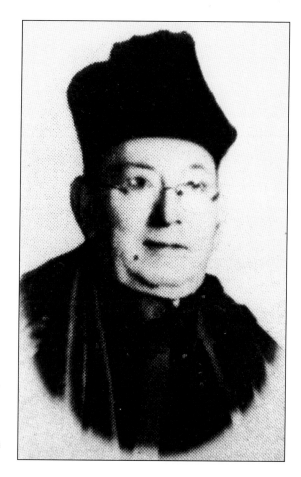

Msgr. Joseph Farrell was born in New York City in 1873. Father Farrell was ordained by John Cardinal Farley in 1900. Following his ordination, he was assigned to St. Peter's parish and started St. Peter's Boys High School in 1916. In 1917, he became pastor of St. Ann's Church and remained there until he became pastor of St. Peter's Church in 1926. Father Farrell was named pastor of St. Peter's Church and held that position for 34 years. In 1935, Father Farrell was named a monsignor by papal decree. The monsignor died in 1960. Monsignor Farrell High School, named in his honor, opened in 1961. (Author's collection.)

Moore Catholic High School was named for Mary Young Moore. Moore was given the title of papal countess by the Vatican in recognition for her good works and generosity. Founded in September 1962, under the leadership of the late Francis Cardinal Spellman and the Presentation Sisters of Staten Island, Moore Catholic High School was the first archdiocese high school for girls on Staten Island. The Moore fortune was made from the Moore-McCormick line of luxury cruise ships. Moore Catholic High School is now coeducational. (Author's collection.)

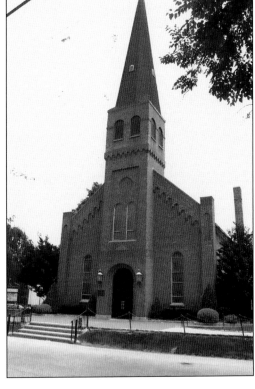

The cornerstone for St. Patrick's Church in Richmond Town was laid on the feast of St. Patrick on March 17, 1862. The land for the church was purchased by Fr. John Barry, who served as the first pastor. At the time there were only four Catholic churches on Staten Island: St. Peter's, St. Joseph's, St. Mary's Port Richmond, and St. Mary's Rosebank. (Author's collection.)

Fr. John Barry was the first pastor of St. Patrick's Roman Catholic Church in Richmond Town. Father Barry was born in Cork, Ireland, in 1830, and he came to the United States in 1850. He was instrumental in establishing Catholic churches on Staten Island. Father Barry served as pastor of St. Patrick's from 1862 to 1884.

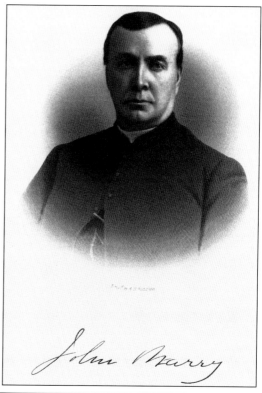

This photograph shows St. Paul's School in New Brighton. Many Irish Catholic New Brighton students were educated at St. Paul's. Unfortunately, due to budgetary concerns, the school has closed. (Author's collection.)

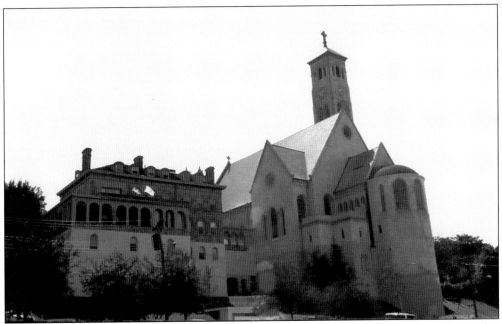

John Murphy Farley was born in Armagh, and he came to New York in 1870. He began his studies at the seminary and became a curate at St. Peter's. The future cardinal was there from 1870 to 1872. The tower of St. Peter's Church was named the Cardinal's Tower in honor of Cardinal Farley. The tower is a landmark visible to sailors at sea. (Author's collection.)

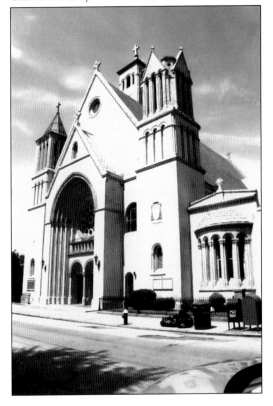

St. Peter's Roman Catholic Church is seen here. The first pastor of St. Peter's was a Spaniard, Fr. Ildefonso Medrano. Another pastor, Fr. Patrick Murphy, died from cholera after ministering to many of the ill at the quarantine. Father Murphy's body was taken by barge from the quarantine to St. Peter's, where he was laid rest beneath the altar. The first St. Peter's Church was destroyed by fire. The present Gothic structure was dedicated on Thanksgiving Day 1903.

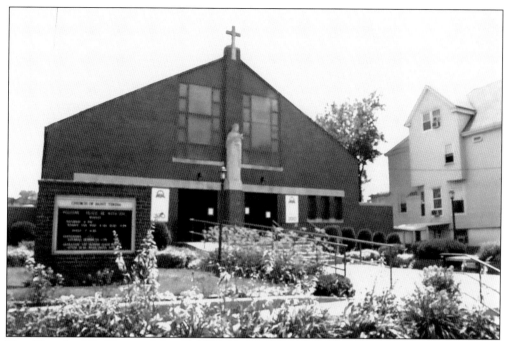

The Church of St. Teresa of the Child Jesus, a Roman Catholic church, is seen here. The first pastor of St. Teresa's, located on Victory Boulevard, was Msgr. Phillip Conran. The church was organized in 1926.

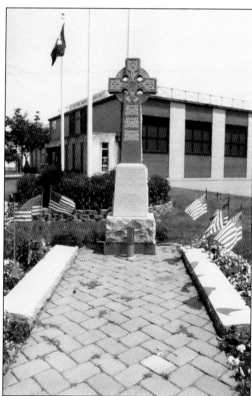

This memorial was erected on the church grounds to honor those parishioners who died on September 11. Staten Island lost 235 people in the September 11 attacks on the World Trade Center. (Author's collection.)

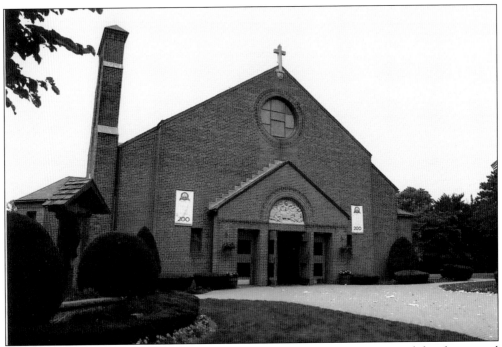

Blessed Sacrament on Forest Avenue is the location of the reviewing stand for the annual St. Patrick's Day parade. (Author's collection.)

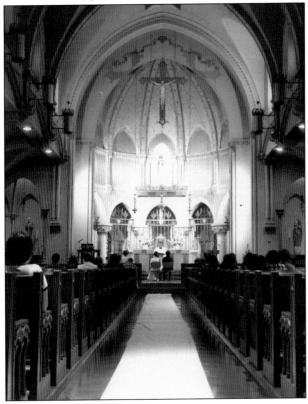

Sacred Heart is located on Castleton Avenue. Seen here is an interior shot of the church. (Courtesy of Joe Scozarri.)

Our Lady of Star of the Sea School is located on Amboy Road in Huguenot. The church has been in existence since its founding in 1916. The church's first rector was James Malloy. (Author's collection.)

St. Peter's Boys High School was built in 1937 on the site of the Nicolas Muller Estate. The previous location was at the present site of St. Peter's Girls High School Richmond Terrace. Msgr. Joseph Farrell was instrumental in starting the high school. (Author's collection.)

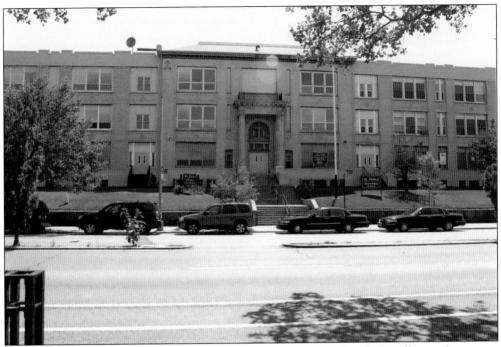

St. Peter's Girls High School was formerly the boys' high school. (Author's collection.)

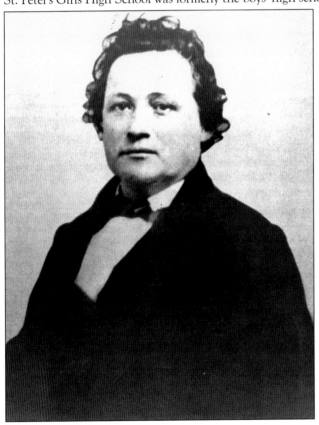

Fr. John Drumgoole, the founder of Mount Loretto, is seen on the cover of the *Anthonian*. Drumgoole was born in Longford, Ireland, in 1816 and immigrated to New York in 1824. In 1881, he built the Mission of the Immaculate Virgin in Manhattan on Lafayette and Great Jones Streets. In 1883, Mount Loretto was established on a farm purchased in Pleasant Plains. The founding of Mount Loretto did much to stop the practice of sending hundreds of Irish orphans out to the West. Mount Loretto continues to provide a variety of services for children in need. (Courtesy of the Staten Island Historical Society.)

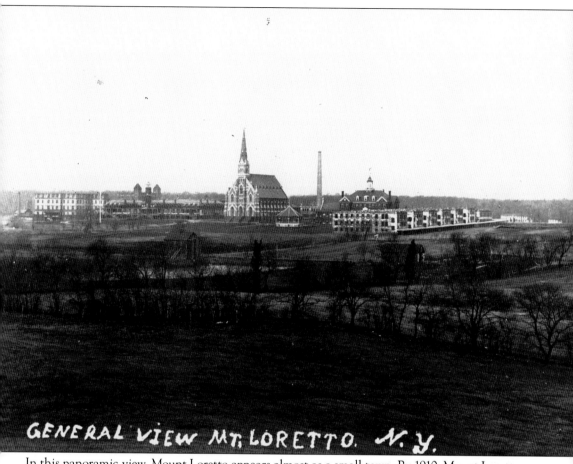

GENERAL VIEW MT. LORETTO. N.Y.

In this panoramic view, Mount Loretto appears almost as a small town. By 1910, Mount Loretto served 2,800 children. In the center of this photograph is the church St. Joaquin. Initially serving boys, Mount Loretto expanded to include girls. In addition to basic education, the mission provided training in areas such carpentry, printing, tailoring, and electrical work. (Courtesy of the Staten Island Historical Society.)

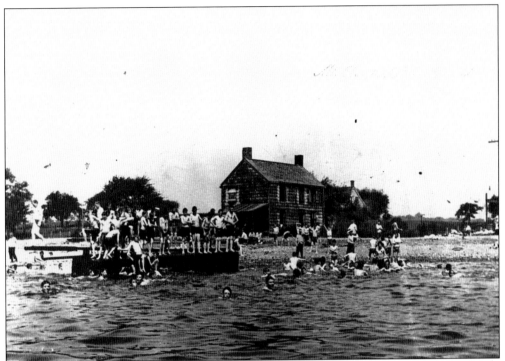

Children are photographed swimming at Mount Loretto around the early 20th century. A mile of beachfront on Prince's Bay afforded excellent recreation for the children. Mount Loretto was also known as Mission of the Immaculate Virgin for the Protection of Homeless and Destitute Children. (Courtesy of the Staten Island Historical Society.)

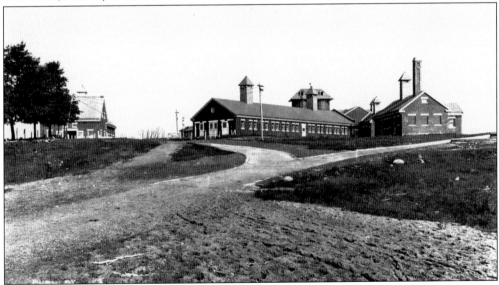

This photograph of the barn was taken by W. J. Grimshaw. At one time it was said to be the largest barn in New York State. The barn burned in 1912. By the 1960s, Mount Loretto encompassed 645 acres, and it had an elementary school, vocational school, convent, administration building, dormitories, gymnasiums, infirmary, and laundries. (Courtesy of the Staten Island Historical Society.)

This photograph shows St. Patrick's School. In 1959, a few years before St. Patrick's Church celebrated its centennial, the parish completed the construction of the elementary school. The school, located on Richmond Road, provides education from kindergarten through eighth grade. (Author's collection.)

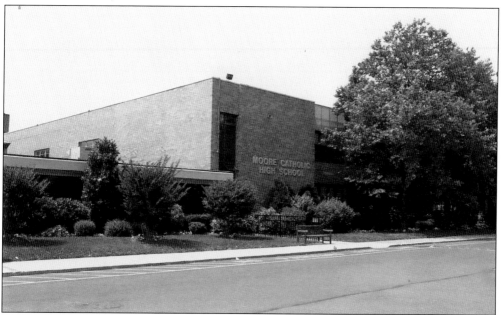

Moore Catholic High School is located at 100 Merrill Avenue in Graniteville. The archdiocesan high school began as a girls' high school and started with a class of 127. Sr. Mary Vincent of the Presentation Sisters was the school's first principal. The school presently serves more than 1,000 students.

Monsignor Farrell High School, named in honor of Msgr. Joseph Farrell, is located on Amboy Road. The monsignor's efforts helped to advance the cause of Catholic education on Staten Island. The California modern building was dedicated on June 2, 1963, by His Excellency Francis Cardinal Spellman. The school's first principal was Rev. Emmet Nevin. The school, which serves 1,200 students, was one of 16 schools named a "Super High School" by the *Daily News*. (Author's collection.)

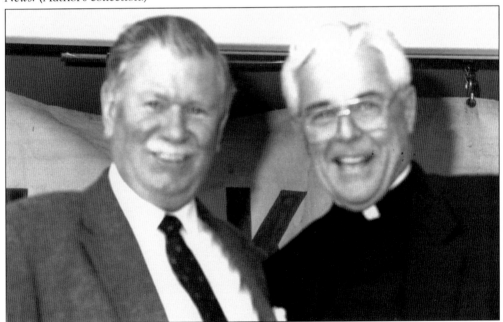

Supreme Court judge Peter P. Cusick and Bishop Patrick Ahearn are pictured at the 1990 St. Patrick's Day parade. (Courtesy of Mimi Cusick.)

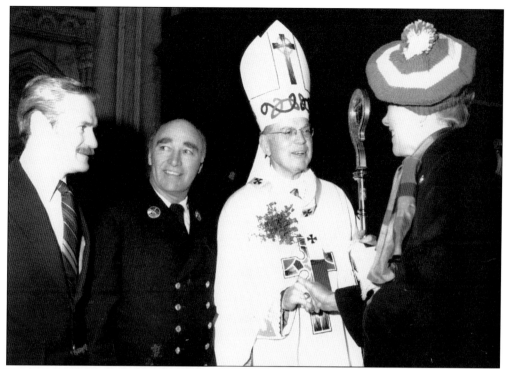

Terence Cardinal Cook greets Elizabeth Connelly. The cardinal, who was known for his civility and affable nature, maintained a traditional view on church matters. (Courtesy of Robert Connelly.)

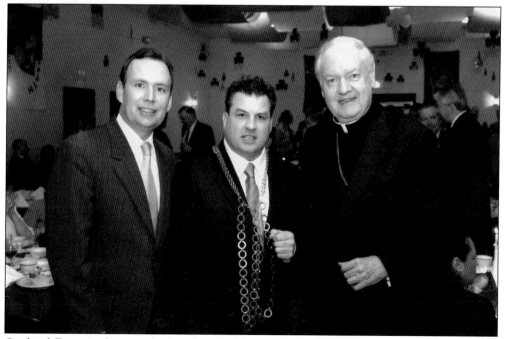

Cardinal Egan is photographed with assemblyman Michael Cusick (left) and Mayor George Lawler of Wexford, Ireland, at an Irish legislators' dinner.

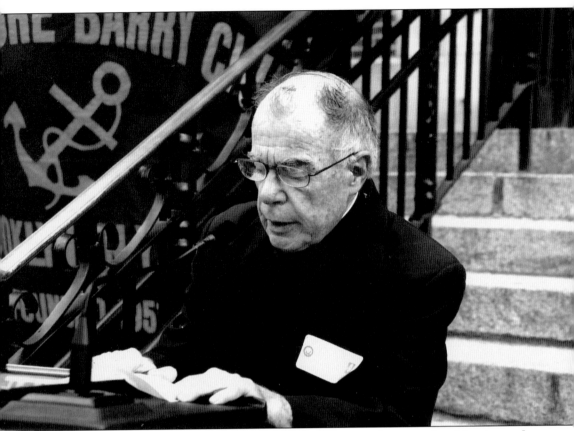

Msgr. James Dorney speaks at the Commodore Barry award ceremonies. Monsignors James Dorney and Peter Finn are co-vicars for the borough. The highly regarded Monsignor Dorney is the pastor of St. Peter's Church, and he also heads St. Peter's Boys and Girls High Schools, along with the elementary school. (Courtesy of Jim Romano.)

Four

FRIENDS AND FAMILIES

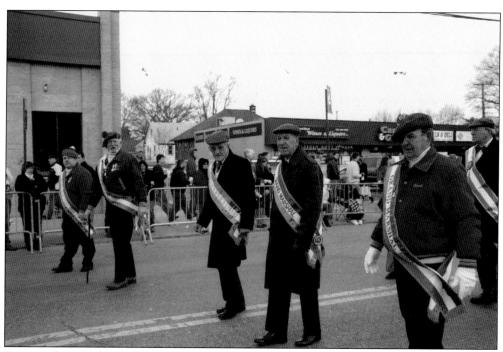

Past grand marshals march together. Pictured from left to right are James Haynes, Bill Reilly, Ray Taylor, Brother Peter Lyons, and Donald McAndrews. (Courtesy of Jim Romano.)

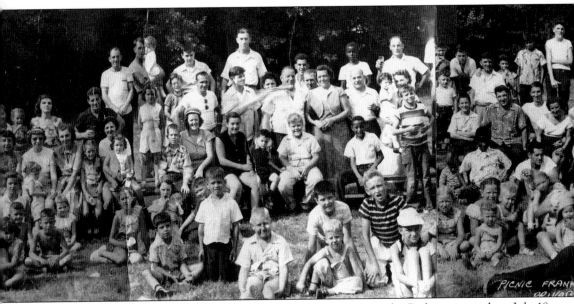

The annual Frank Murphy Trucking employee picnic at Privacky Park is pictured on July 18, 1953. Murphy Trucking, a large firm located on Richmond Terrace in New Brighton, employed

EMPLOYEES BENEVOLENT ASS.N. INC.
IIII V 18 1953

many Staten Islanders. Frank Murphy was the father of congressman John M. Murphy. (Courtesy of Ted and Noreen Harris.)

First communion is a rite of passage for many Irish Catholic children. Patricia (Patty) Reilly is pictured on the occasion of her first communion. Patty is the daughter of Thomas Reilly and Helen Byrne Reilly. (Courtesy of Patricia Reilly Driscoll.)

The Smith family celebrates the parents' 45th wedding anniversary at the Columbian Lyceum. Margie Smith was the former Margie Meehan. The Meehan family traces its roots back to County Meath. James Smith's mother was Molly Farley with roots in County Cavan. Son Jim Smith is the oldest of the 10 children. As Jim Smith said, "With all those kids and one of the Island's largest families, we were very well known in West Brighton and points beyond on Staten Island." (Courtesy of Jim Smith.)

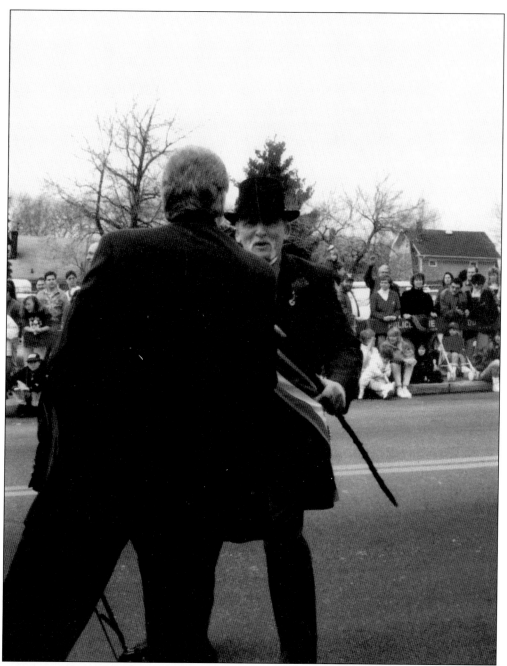

Grand marshal Bill Reilly steps over to greet a friend at the Staten Island St. Patrick's Day parade. Reilly, a retired New York City firefighter and a marine corp veteran, is active in many island community and charity events. A past president of the Ancient Order of Hibernians and a fifth-generation Irish Staten Islander, Reilly was one of the founding members of the Irish Cultural Center. He has been especially active in advocating for honoring the remains of those immigrants who died at the quarantine hospital. (Courtesy of Bob Burmeister.)

The annual St. Patrick's Day parade on Forrest Avenue draws a large crowd. Jacqueline Byrne Ryan and Lily, the fox terrier, are "wearing the green," decked out for the occasion. Jacqueline is the mother of Kelly, Erin, and Shannon. (Courtesy of Ted and Noreen Harris.)

Deidre Tighe, granddaughter of Ted and Noreen Harris, makes a beautiful "Irish princess" on St. Patrick's Day. Tighe has roots in Counties Cork, Cavan, and Donegal. (Courtesy of Ted and Noreen Harris.)

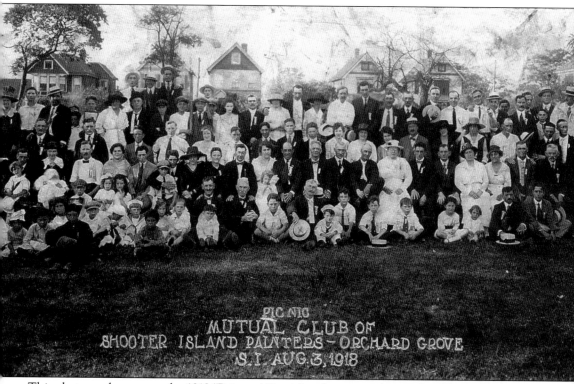

This photograph captures the 1918 "Painters' Picnic" gathering on August 3 in Elm Park of the Shooters Island Painters of Orchard Grove. Present in the center are a number of ancestors of the Rogers family, which included the Dooley, Welsh, Egan, and Byrne clans. The island was home to several shipbuilding firms, including Townsend and Downey, and later during World War I, Standard Shipbuilding. In 1902, Townsend and Downey built Kaiser Wilhelm's yacht the *Meteor*. (Courtesy of Lynn Rogers.)

Thomas Reilly was born on Staten Island and married Helen Byrnes, a daughter of Owen Byrne. The Reillys had seven children. (Courtesy of Patricia Reilly Driscoll.)

Thomas Reilly (right) was a career submarine officer. In 1937, he attempted to rescue two young boys who had fallen through the ice at Clove Lake. He dove in repeatedly but was unable to save the boys. Reilly received the navy and marine corps medal for bravery. After retiring from the navy, he went to on become a captain on the Staten Island Ferry. (Courtesy of Patricia Reilly Driscoll.)

The Franzreb family is pictured during the St. Patrick's Day parade. The annual parade along Forrest Avenue draws many participants and visitors, and it rivals the annual Travis Fourth of July celebration. The Franzreb family owned the Clove Lake Riding Stables for many years. The picturesque red barn of the stables located on Clove Road was a familiar landmark to many Staten Islanders until it was demolished to make way for housing. (Courtesy of the Franzreb family.)

From left to right, Mark Zink, Steve Havesi, and Joe and Roe McAllister are photographed on the South Beach Boardwalk. Joe is a member of the Ancient Order of Hibernians, Division 4. Both Joe and Roe are actively involved in the South Beach Civic Association. (Courtesy of Jim Romano.)

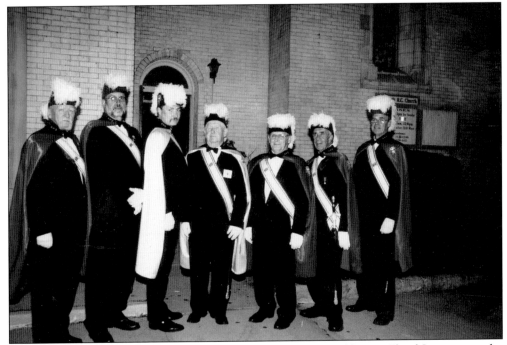

The Knights of Columbus are pictured lining up for services led by Jim Flood Jr., wearing the white cape. (Courtesy of Jim Romano.)

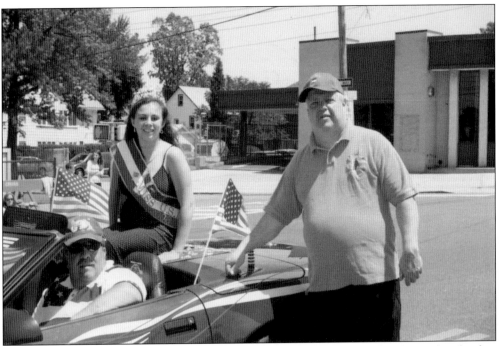

Ericka O'Rourke, beauty pageant winner, poses with James Haynes. O'Rourke is also the first winner of the Catholic Veteran's Award. (Courtesy of Jim Romano.)

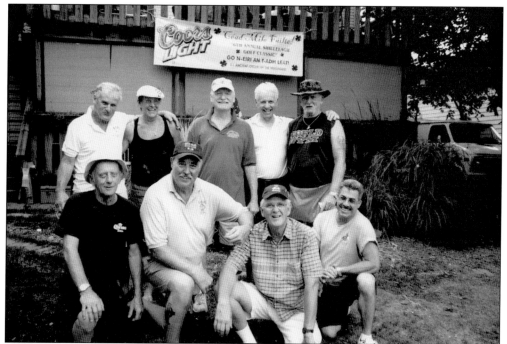

Players from Division 4 of the Ancient Order of Hibernians pose for a photograph at the Annual Shillelagh Golf Classic. They are, from left to right, (first row) Vinnie Cousins, Brian Nutley, Walter Osborne, and Joe McAllister; (second row) Joe O'Sullivan, Bev O'Sullivan, Jimmy "Texas" Brown, and Bill Reilly. (Courtesy of Jim Romano.)

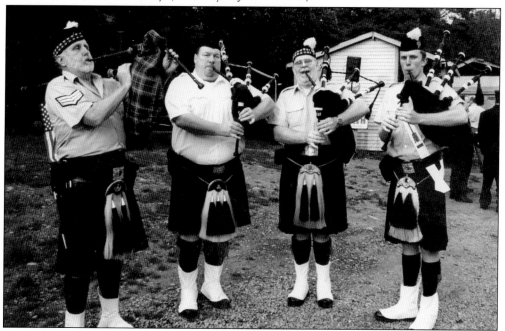

The Staten Island Pipers tune up. The group, which has been in existence for 40 years, is dedicated to the preservation of Celtic music and offers lessons with these instruments. (Courtesy of Jim Romano.)

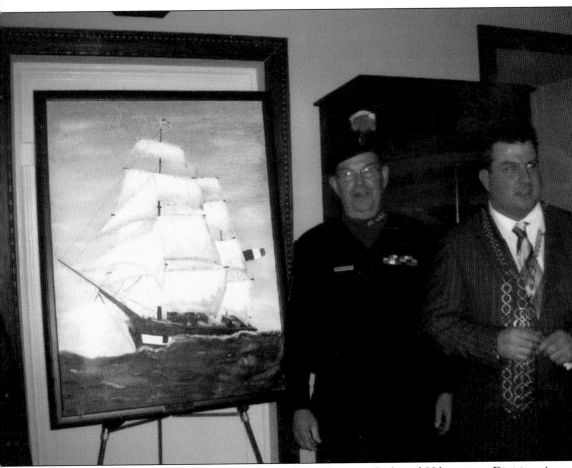

On March 13, 2008, Donald McAndrew of the Ancient Order of Hibernians, Division 4, presents Wexford mayor George Lawler with a painting of the famine ship *Jeannie Johnson* that he painted. The mayor has been very active in keeping ties with Irish Americans. (Courtesy of Donald McAndrews.)

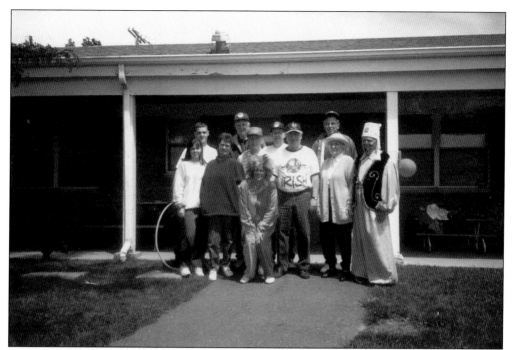

Volunteers from Division 4 of the Ancient Order of Hibernians and Volunteers of America pose at the annual picnic the organizations sponsor for the Early Learning Center. The Early Learning Center serves children with disabilities until age five. Police officers and firefighters have joined in, and the event has become very popular. (Courtesy of Donald McAndrews.)

New York City Department of Corrections piper Joe Korber pauses for a moment during the parade. (Courtesy of Jim Romano.)

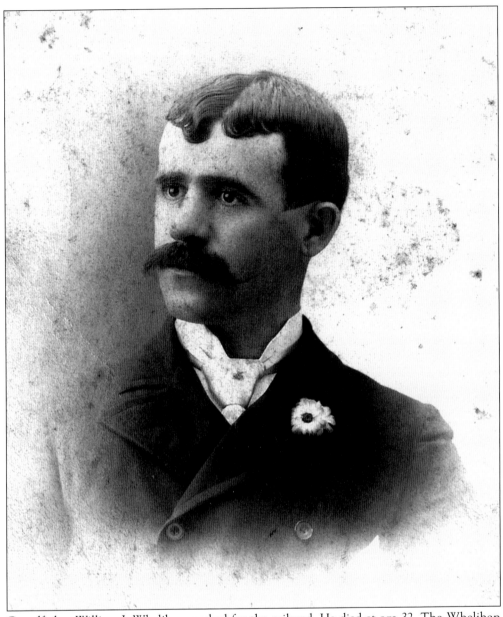

Grandfather William J. Whelihan worked for the railroad. He died at age 32. The Whelihan family had roots in Inishskeelen, Ireland. (Courtesy of Judy Dini.)

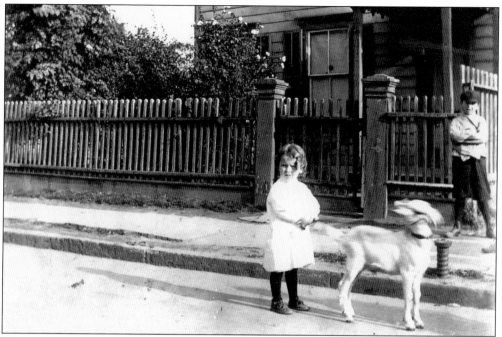

This photograph is titled "Daddy and the goat." William "Bo" Whelihan poses on the left with his pet goat. Whelihan got the lifelong nickname of Bo from his sister, who could not say brother. (Courtesy of Judy Dini.)

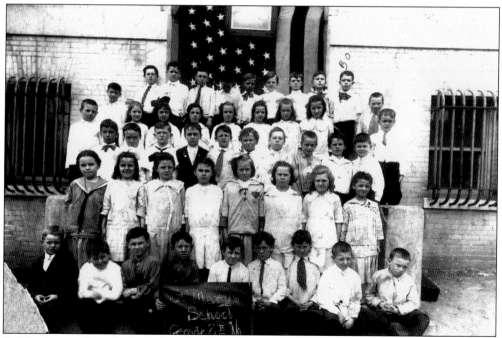

St. Mary's second-grade class in Rosebank poses for a group photograph around 1910. Bo Whelihan is the last child on the right in the fifth row. The Church of St. Mary of the Miraculous Medal began in 1886, and the first pastor was Fr. John Lewis. He served for many years in an Irish and German section of Rosebank. (Courtesy of Judy Dini.)

Pictured here is a South Beach family gathering in the 1920s. Oude Dorp (Old Town) was located at the foot of Ocean Avenue, South Beach. It was the site of the first settlement of Dutch and French immigrants in 1661. From the 1880s to the 1920s, South Beach was a popular resort. (Photograph by Weitzman, Stapleton; courtesy of Judy Dini.)

These ladies pose at South Beach in 1938. Agnes Cornell is kneeling. (Courtesy of Judy Dini.)

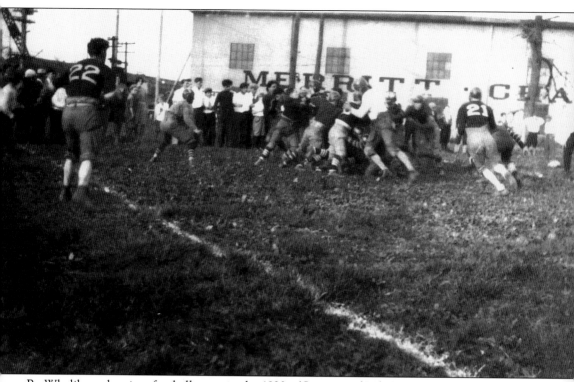

Bo Whelihan plays in a football game in the 1920s. (Courtesy of Judy Dini.)

WARNING

1 **Punishments ranging as high as Ten Years' Imprisonment or $10,000 Fine, or Both,** may be imposed under United States Statutes for violations thereof arising out of infractions of Rationing Orders and Regulations.

2 **This book must not be transferred.** It must be held and used only by or on behalf of the person to whom it has been issued, and anyone presenting it thereby represents to the Office of Price Administration, an agency of the United States Government, that it is being so held and so used. For any misuse of this book it may be taken from the holder by the Office of Price Administration.

3 In the event either of the departure from the United States of the person to whom this book is issued, or of his or her death, the book must be surrendered in accordance with the Regulations.

4 Any person finding a lost book must deliver it promptly to the nearest Ration Board.

War Ration Book One

UNITED STATES OF AMERICA

OPA Form No. R-302

Certificate of Book Holder

the undersigned, do hereby certify that I have observed all the conditions and regulations governing the issuance of this War Ration Book; that the description of Book Holder contained herein is correct; that an application for the issuance of this book has been duly made by me or on my behalf; and that the statements contained in said application are true to the best of my knowledge and belief.

(Signature of, or on behalf of, Book Holder)

[Book Holder's Own Name]

Any person signing on behalf of Book Holder must sign his or her own name below

(Father, Mother, or Guardian)

indicate relationship to Book Holder

Certificate of Registrar

This is to Certify that pursuant to the Rationing Orders and Regulations administered by the OFFICE OF PRICE ADMINISTRATION, an agency of the United States Government,

(Name, Address, and Description of person to whom the book is issued:)

(Last name)	(First name)	(Middle name)

(Street No. or P. O. Box No.)		(Street or R. F. D.)

(City or town)	(County)	(State)

ft.	in.	lbs.			yrs. Sex { Male / Female
(Height)	(Weight)	(Color of eyes)	(Color of hair)	(Age)	

has been issued the attached War Ration Stamps this day of 1942, upon the basis of an application signed by himself ☐, herself ☐, or on his behalf by his or her husband ☐, wife ☐, father ☐, mother ☐, exception ☐. (Check)

(Registrar) (Signature)

Local Board No. County State

Stamps must not be detached except in the presence of the retailer, his employee, or person authorized by him to make delivery.

This World War II ration book was issued to Julia Whelihan. The book notes she is eight months and 1 foot, 11 inches with blues eyes and brown hair. She later married Jack Dini. (Courtesy of Judy Dini.)

Grandmother Margaret Whelihan poses for a photograph with baby Bo.

This photograph shows the Whelihan family in 1912. They are, from left to right, Jack, Eustelle, Bo, and Monica. (Courtesy of Judy Dini.)

Aunts Lizzie and Mamie Whelan pose for the camera. Neither of the sisters ever married. Lizzie, an avid Yankees fan, worked for the post office, while her sister Mamie was employed as a domestic. (Courtesy of Judy Dini.)

A young Bo Whelihan poses in front of a roadster. (Courtesy of Judy Dini.)

Bo Whelihan was a civilian mechanic for the Coast Guard. Part of his work involved maintaining the lighthouse beacons. In the 1930s and 1940s, he was frequently sent to Sandy Hook, New Jersey, to work on lighthouse beacons. (Courtesy of Judy Dini.)

The Whelan's Hardware Store, owned by Ellen and John Whelan, is pictured in 1938. The store was located in Grasmere. (Courtesy of Judy Dini.)

Judy Whelihan Dini and her mother, Julia Whelihan, are photographed in front of 432 Seabreeze Avenue. The front of the house faced the boardwalk, while the back faced the street. The Franklin Delano Roosevelt Boardwalk seen in the background was begun in 1935. (Courtesy of Judy Dini.)

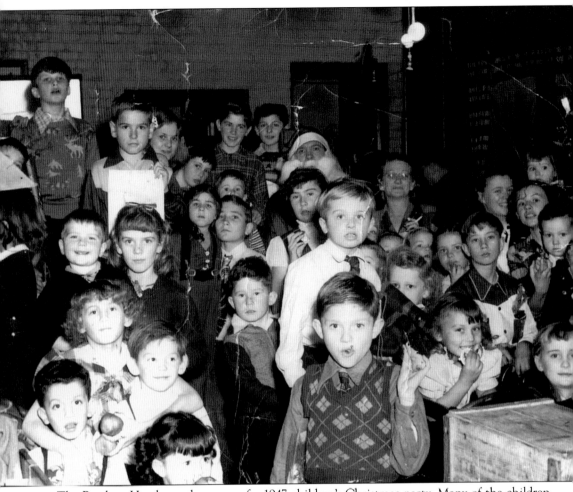

The Breakers Hotel was the scene of a 1947 children's Christmas party. Many of the children were residents of Warren Manor and Ocean Breeze. Both of those areas were home to a large number of Irish residents. (Courtesy of Judy Dini.)

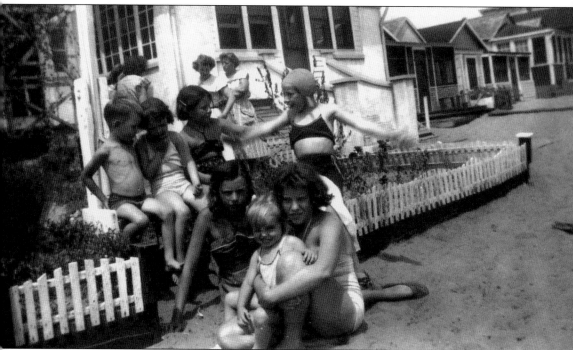

A group of children are photographed in front of the Whelihans' home in the 1950s. While the Whelihans' home was a year-round residence, most of the homes in the area were summer homes. Small bungalows that were typical of the area are visible in the background. (Courtesy of Judy Dini.)

Theatrical productions were a specialty at 432 Seabreeze Avenue in the 1950s. Pictured from left to right, Judy and her sister Trudy pose with friends Rita Labelle and Mary Ann Menendez. The two girls on the right are unidentified. (Courtesy of Judy Dini.)

A crowded Sunday at South Beach is pictured. Thousands of visitors would come by train or boat to South Beach. Happyland, an amusement park in the tradition of Coney Island's Steeplechase and Luna Park, opened in 1906. There were fires in 1917 and later in the 1920s that destroyed much of the area. (Courtesy of Judy Dini.)

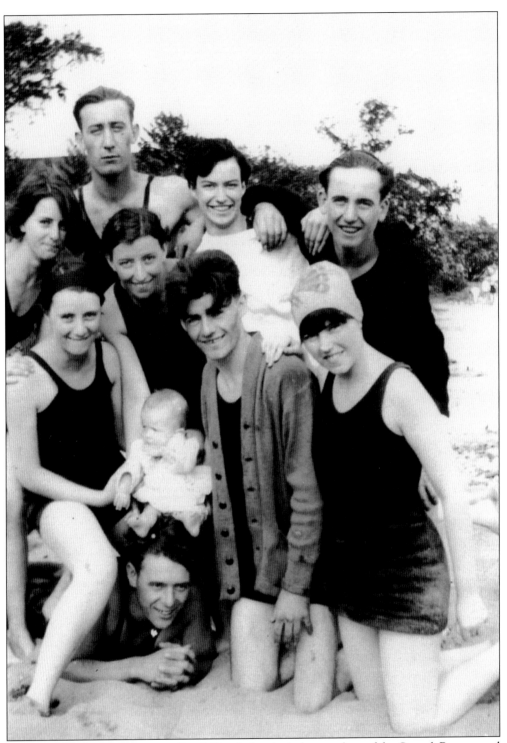

This photograph shows a group at South Beach that includes members of the Cornel, Barnes, and Whelihan families. All the families were members of St. Mary's parish in Rosebank. (Courtesy of Judy Dini.)

Bo and Julia Mary Whelihan pose for the camera. Mary's family members, on her mother's side, were McCormacks who came from Greenwich Village in New York. (Courtesy of Judy Dini.)

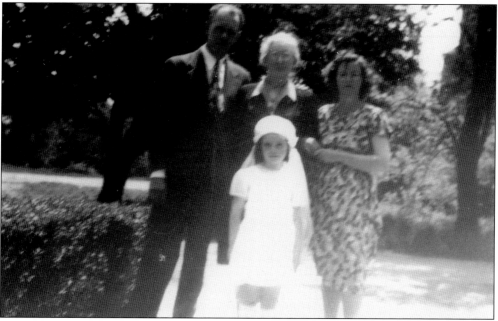

Judy Dini celebrates her first communion with mother, father, and grandmother. Judy started school at St. Mary's in Rosebank and later transferred to St. Margaret Mary's in Midland Beach. She married Jack Dini, and the couple has three children. (Courtesy of Judy Dini.)

The Whelan sisters pose at a family gathering in the 1950s. Visible in the background is the refrigerator with the motor on top. (Courtesy of Judy Dini.)

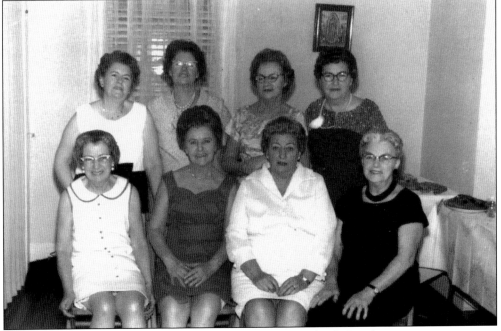

The Whelan family poses at a family gathering. (Courtesy of Judy Dini.)

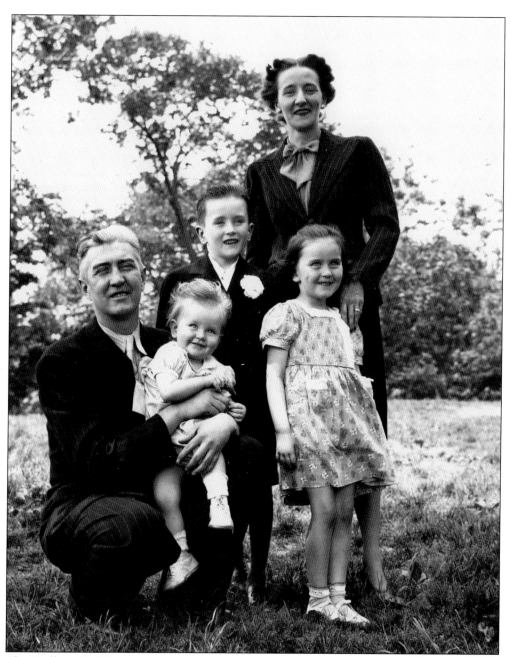

The Spillane family of Midland Beach is photographed on the occasion of son Richard's communion in 1946. Pictured from left to right are Edward Healy Spillane, Regina Spillane (became Von Bevern), Richard D. Spillane, Jessie M. Spillane, and Sheila Spillane (became Michaud). The Spillane family came from Devil's Bit, County Tipperary, and the Healys came from Cahirciveen, County Kerry. Jessie lived in Hell's Kitchen in Manhattan during the winter and summered at Midland Beach. (Courtesy of Sheila Spillane Michaud.)

Cornelius Fitzpatrick was sexton of Blessed Sacrament Church. Fitzpatrick was one of 10 children born in Cullen, County Cork, in 1906. He came to New York in 1930 and worked at Bethlehem Steel and later the Singer Sewing Center. In the late 1950s, he became a custodian for Blessed Sacrament School along with his brother, John. By 1960, he was the sexton of the church and remained there until his retirement in the late 1970s. He was so well liked and respected that he continues to be remembered by many Staten Islanders. (Courtesy of Mary Fitzpatrick.)

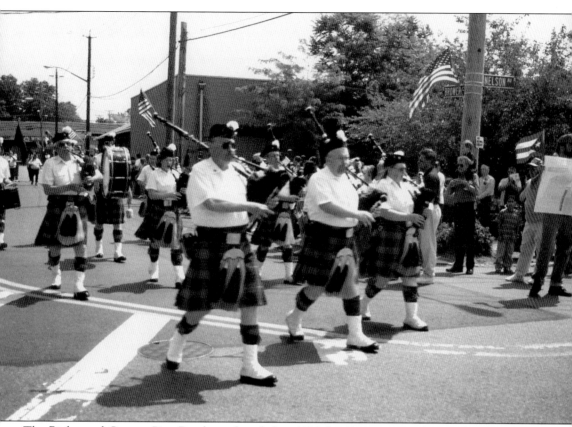

The Richmond County Pipe Band was founded in 1976. Jim Romano marches in the parade. (Courtesy of Mary Fitzpatrick.)

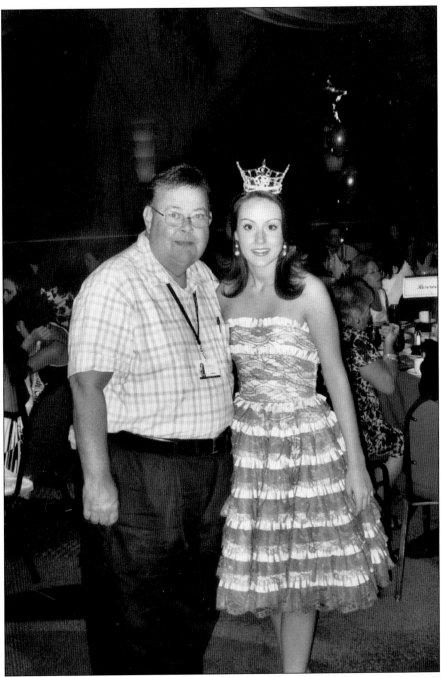

Jim Smith poses with Maria DeSantis of Staten Island, Miss America's Outstanding Teen 2006. For 40 years, Smith has volunteered with the Miss Staten Island Pageant, which is an official Miss America preliminary. Every year, Miss Staten Island competes next for Miss New York and a chance to be Miss America. Smith is currently the executive director of the pageant. In 1969, Smith, a member of the Ancient Order of Hibernians, started the Miss Hibernia pageant to choose a queen of the island's St. Patrick's Day parade on Forest Avenue. (Courtesy of Jim Smith.)

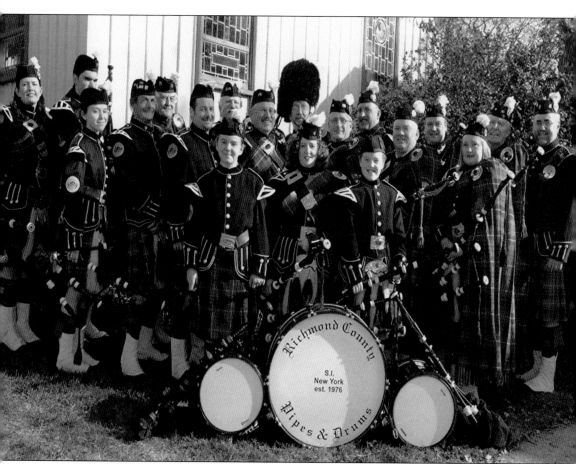

The Richmond Pipers pose together. From left to right are (first row) Skye Wright, Catherine Travers, and Paul Travers; (second row) Samantha Wright, Tom Merrick, Bobby Kelly, Laurence Ronan, John Travers, Sean Walters, and Kathy Travers; (third row) Kathy O'Keefe, Michael Fedele, Walter Askew, Jon Kanter, Joe Hummers, John Hartmann, Matt Travers, Jack Fitzpatrick, and Dan Campbell. (Courtesy of Jim Romano.)

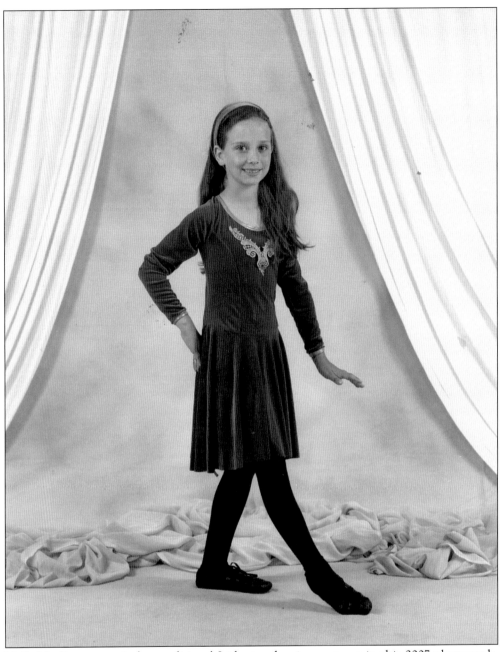

Halle Vitaliano poses in her traditional Irish step-dancing costume in this 2007 photograph. Lessons in traditional Irish step dancing are given by Staten Island Dance Theatre. (Courtesy of Helen and Eric Vitaliano.)

The New York Police
Marching Band performs at
the Staten Island St. Patrick's
Day parade. (Courtesy of
Peggy and Tom Lindsey.)

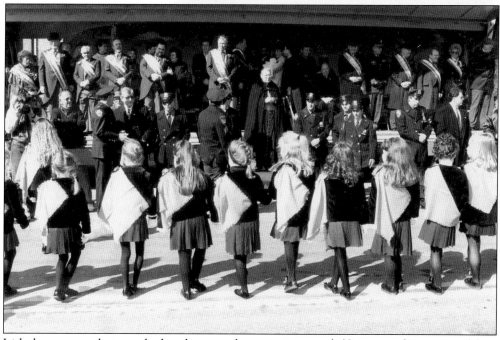

Irish dancers are photographed as they pass the reviewing stand. (Courtesy of Mimi Cusick.)

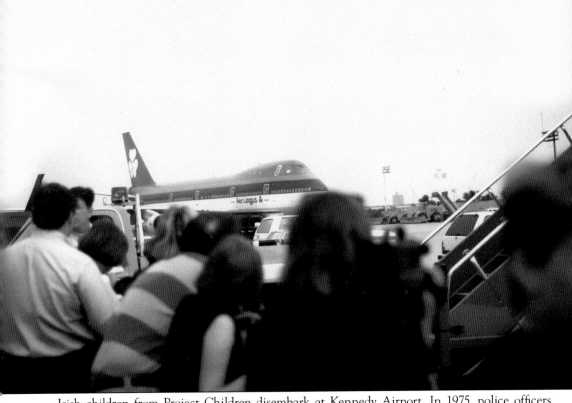

Irish children from Project Children disembark at Kennedy Airport. In 1975, police officers Denis and Pat Mulcahy started Project Children to bring Catholic and Protestant children from northern Ireland to the United States for the summer. The purpose was twofold: give the children a summer away from the political troubles of Ireland and give them a chance to know each other. Since its inception, more than 16,000 children have spent summers in America. Detective Denis Mulcahy has been nominated twice for the Nobel Peace Prize. (Courtesy of Dorothy and John Hurley.)

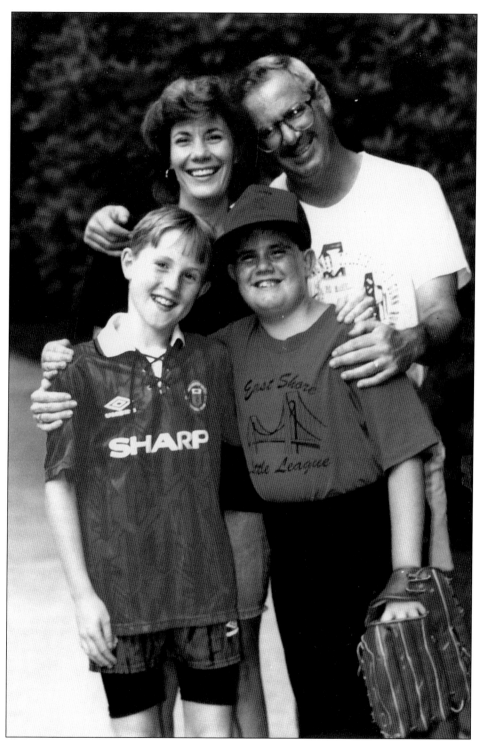

Parents John and Dorothy, and son Terrence Hurley (right) pose with their summer guest, David Mulgrew, in the summer of 1993. The success of Project Children is based upon the hospitality of host families. (Courtesy of Dorothy and John Hurley.)

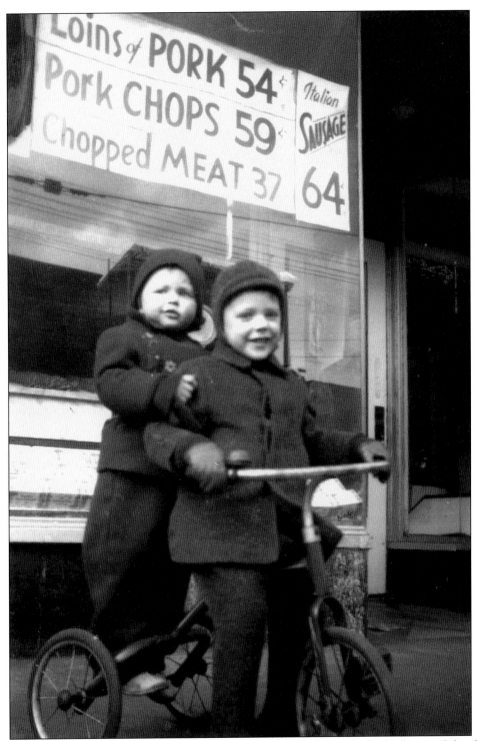

The White Rose Butcher Shop, at 177 Broad Street in Stapleton, is the background for the photograph of Art Silva and Bob Burmeister taken around 1947. Pork chops are advertised at 59¢ a pound. (Courtesy of Bob Burmeister.)

From left to right, Christine White, Pauline Healey, and Marion Healey pose for this photograph in 1947. (Courtesy of Bob Burmeister.)

Bob Burmeister (left) and Jim Rodgers attend the Darrows St. Patrick's Day party in 1989. (Courtesy of Bob Burmeister.)

A group of five friends pose for a photograph. From left to right are Jimmy Hogan, Pat Scollan, Paul Sussex, Charles Miller, and George Mallen. (Courtesy of Peggy and Tom Lindsey.)

Pictured here, from left to right, are Tom and Peggy Lindsey, and Peggy's mother Pat Burmeister, and Charles Miller at the 1999 parade. (Courtesy of Peggy and Tom Lindsey.)

The Irish Cultural Center will be newly housed at Snug Harbor Cultural Center. The idea for the center began with Bill Reilly, Don Mc Andrews, Bob Nelson, Jim Haynes, Bill Powers, and Kevin and Tom Reilly in 1995. The center was originally housed in a room at Mount Loretto before moving to Flagg Place. The original members contributed to the support of the organization. The center sponsors an annual two-day Spring Irish Festival that features Irish crafts and memorabilia. The center has a collection of Irish books and materials related to Irish history. Step-dancing lessons are offered, and an Irish color guard is available. (Author's collection.)

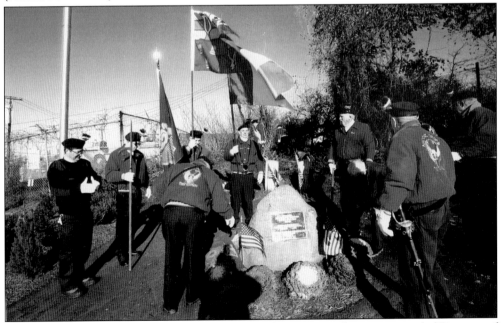

Members of Division 4 of the Ancient Order of Hibernians tend to a memorial. (Courtesy of Donald McAndrews.)

Thomas "T. A." Ryan poses at a reunion of the Harris family. T. A. worked in security at St. Vincent's Hospital. He was married to Jackie Byrne and was the father of three girls. T. A. was known to many Staten Islanders who would go through the doors of St. Vincent's. He died at age 63 of cancer. (Courtesy of Ted and Noreen Harris.)

Tom Lindsey poses with his son, Thomas. Thomas was diagnosed at the age of five months with tuberous sclerosis. The disease has devastating effects that range from cognitive impairments to seizure. Since their son's diagnosis, Peggy and Tom Lindsey have worked to increase funding for research for the disease. While taking Thomas to a hospital appointment in New York, Tom Lindsey saw actress Julianne Moore on the street. He approached the actress with Thomas, whose head was bandaged from a recent surgery, and asked Moore if she could appear at fund-raiser for Thomas. Since then Moore has been actively involved in this cause. She recently testified with Tom Lindsey before Congress on the need for additional funding to research cures for this devastating disease.

As part of their efforts to increase awareness, the Lindseys have sponsored several events to raise money for tuberous sclerosis. This photograph shows a band performance. (Courtesy of Peggy and Tom Lindsey.)

Tom Lindsay is photographed testifying before Congress on the need for additional funding to research cures for tuberous sclerosis. (Courtesy of TS Alliance.)

The Wolfe sisters pose at the beach in the 1940s. Pictured from left to right, they are Dot Burke, Marguerite (Mar) Harris, Gert Michaud, and Helen Fleming. The sisters, whose father was William Wolfe from County Cork, grew up in New Brighton. (Courtesy of Ted and Noreen Harris.)

From left to right, in the second row, Alice Wolfe, Rita Byrne, Gert Michaud, and Helen Fleming pose at the beach with Joe Byrne, Ted Harris, and Bob Fleming seated in front. Bill Wolfe is at the back. The babies are unidentified. (Courtesy of Ted and Noreen Harris.)

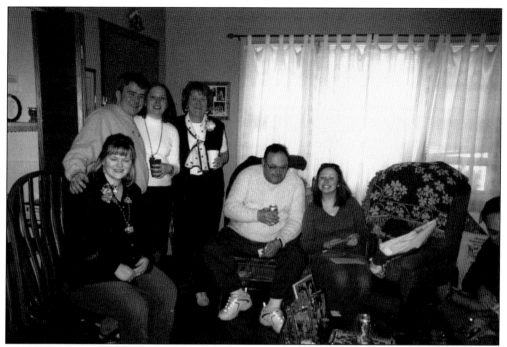

Pictured here is a St. Patrick's party of the Ryans. (Courtesy of Ted and Noreen Harris.)

From left to right, Jackie Ryan, Merrie Lindsey, and Noreen Harris are photographed at the 2001 wedding of Suzanne Harris and Bob Tighe. (Courtesy of Ted and Noreen Harris.)

Actress Julianne Moore is photographed with Ryan Krystof and Deidre Tighe at a fund-raiser for tuberous sclerosis. (Courtesy of Ted and Noreen Harris.)

Five

BUSINESS AND INDUSTRY

This photograph shows the business of Daniel Dempsey, undertaker and embalmer, which was located on Broadway around 1900. There were two locations for the funeral home. One was on Broadway in Staten Island, and the other was in Bayonne. The business, which was in operation from the 1850s to the 1940s, kept detailed records of its clients. In addition to basic information such as age and address, Dempsey kept information as to place of birth. (Courtesy of Lynn Rogers.)

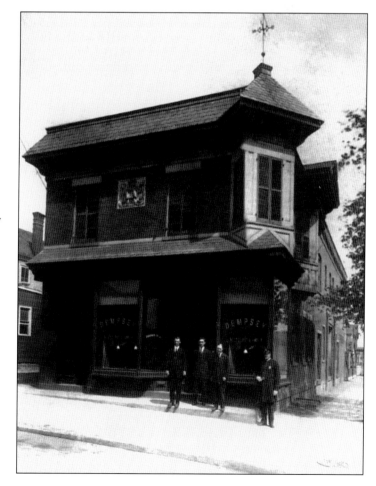

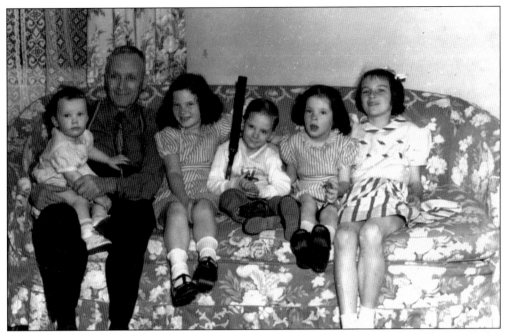

Owen Byrne, the founder of Byrnes Linen and Laundry Supply, is photographed with his grandchildren. Owen Byrnes founded the business in 1916 and operated from a store on Castleton Avenue. Owen Byrne was "the seventh son of the seventh son" and was born on the "night of the big wind." (Courtesy of Patricia Reilly Driscoll.)

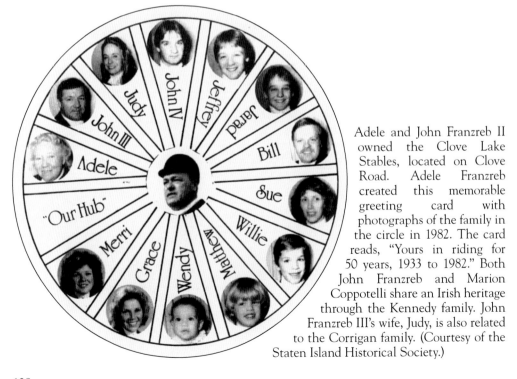

Adele and John Franzreb II owned the Clove Lake Stables, located on Clove Road. Adele Franzreb created this memorable greeting card with photographs of the family in the circle in 1982. The card reads, "Yours in riding for 50 years, 1933 to 1982." Both John Franzreb and Marion Coppotelli share an Irish heritage through the Kennedy family. John Franzreb III's wife, Judy, is also related to the Corrigan family. (Courtesy of the Staten Island Historical Society.)

A bill for a funeral at the Dempsey Funeral Home on August 18, 1897, lists total costs as $390. (Courtesy of Lynn Rogers.)

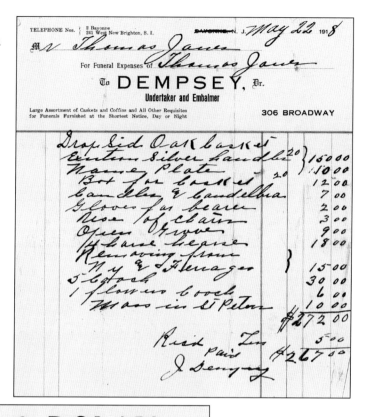

DUNN & DOLAN

Brick Manufacturers

GREEN RIDGE, STATEN ISLAND, N. Y.

A1 RED BRICK
5,000,000 a year

Shipped by water or rail to any part of the United States.

This advertisement is for the brick manufacturing company of Dunn and Dolan. The advertisement appeared in the 1906 book *Staten Island Real Estate and Industry: Information for Homeseekers.* The Dunn and Dolan factory was located in Green Ridge and employed between 30 and 40 workers. (Author's collection.)

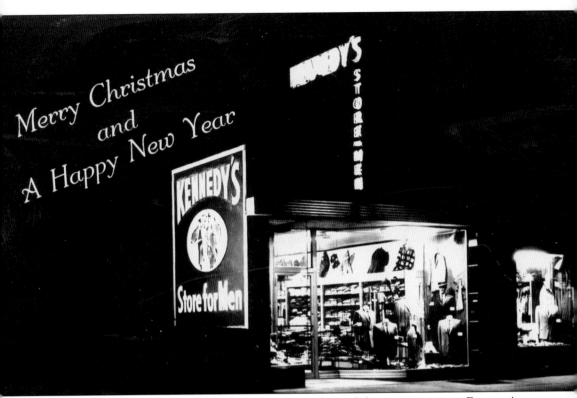

This night shot captures Kennedy's Men's Store located for many years on Forrest Avenue. Charles Kennedy, with help from his wife, Florence, started the business in the family's home on Delafield Avenue. The store used large billboards and innovative sales techniques such as a "suit club" with customers contributing weekly toward the future purchases. Their son Joseph eventually took over the store with help from his brother Dick, sister Corinne, and salesman and tailor Frankie Mezzacappa. Charlie Kennedy also penned a column for the *Staten Island Advance* titled "Kennedy's Komments." (Courtesy of the Kennedy family.)

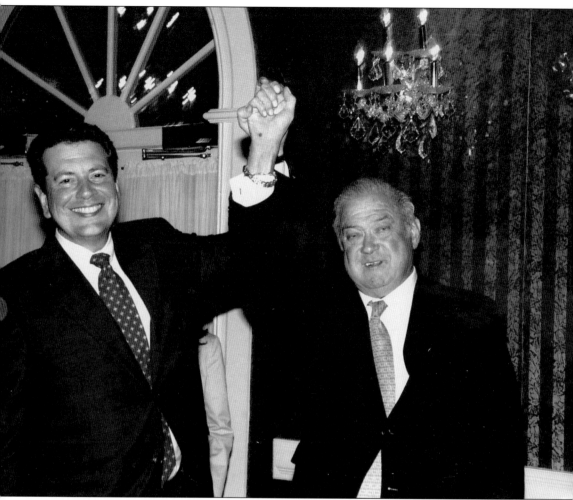

Francis H. (Frank) Powers (right) was one of seven children born in Brooklyn on July 6, 1940. Powers graduated from the manual training high school at the age of 16, and he worked as a runner on the floor of the New York Stock Exchange at age 17. During those early years, he also worked part-time as a florist. By the time he was 23, he was a partner in the firm Faulkner, Dawkins, and Sullivan and the youngest partner in the history of Wall Street. During the mid-1970s, Powers became a partner at Weiss, Peck and Greer, another well-known financial firm on Wall Street. It is there he would stay until his retirement in 2003. (Courtesy of Jim Romano.)

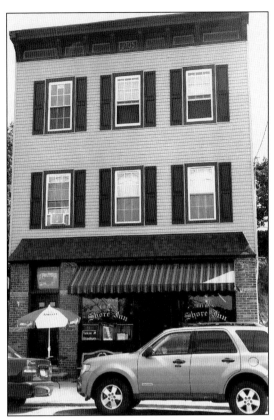

A favorite stopping-off place for the annual St. Patrick's Day parade is Liedy's Shore Inn on Richmond Terrace. (Author's collection.)

The *Staten Island Advance* is seen at its present location on Fingerboard Road. The *Richmond County Advance* was established by John Crawford in 1886. It operated out of a building on Broadway in West New Brighton before moving to Castleton Avenue in 1916. It became a daily in 1918 and was later sold to Staten Island Newhouse and became the *Staten Island Advance*. John Crawford was born in County Cavan. (Author's collection.)

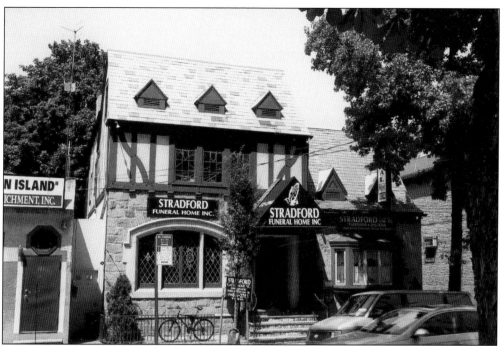

This photograph shows the former location of Casey's Funeral Home on Victory Boulevard. That location was known to generations of Staten Islanders. (Author's collection.)

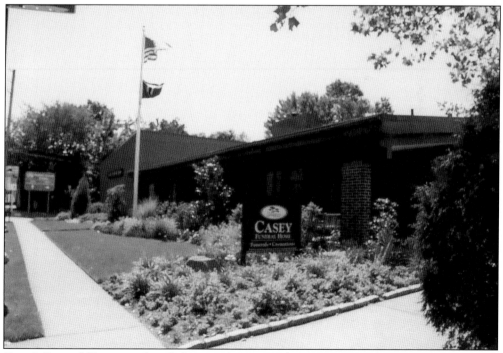

Casey's Funeral Home was founded over 100 years ago by Mary Casey. There are presently three separate locations for the funeral home. The one pictured here is located at Slosson Avenue. (Author's collection.)

Marion and Dominic (Dee) Coppotelli were married in 1938. Marion was the former Marion Kennedy, and the couple ran the popular Staten Island restaurant the Tavern on the Green. The restaurant entertained many celebrities, including Rose and Bobby Kennedy, Joan Crawford, and Richard M. Nixon. The Coppotellis hosted a surprise party for Bobby Thomson following his famous home run called "the shot heard round the world" in the World Series against the Dodgers. (Courtesy of the Coppotelli family.)

Six

SPORTS

Matthew W. (Matty) McIntyre was born in Stonington, Connecticut, on June 12, 1880. McIntyre grew up on Staten Island and played 10 seasons as an outfielder in the major leagues. During his impressive career, he played for the Philadelphia Athletics and Detroit Tigers and finished his career with the Chicago White Sox. McIntyre reached the pinnacle of his career in 1908 when he helped lead the Tigers to the World Series. In 1908, he was among the top five in the American League in batting average, hits, and bases on balls. McIntyre became second in hits behind his teammate Ty Cobb. McIntyre became equally remembered for leading the "anti-Cobb" clique during Cobb's early years. McIntyre died of Bright's disease at age 40. (Author's collection.)

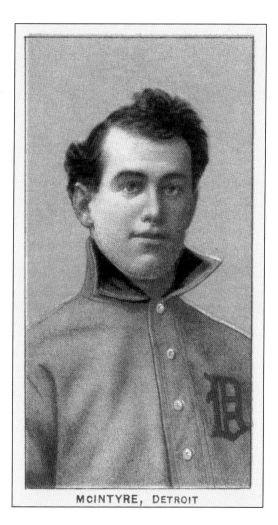

MCINTYRE, DETROIT

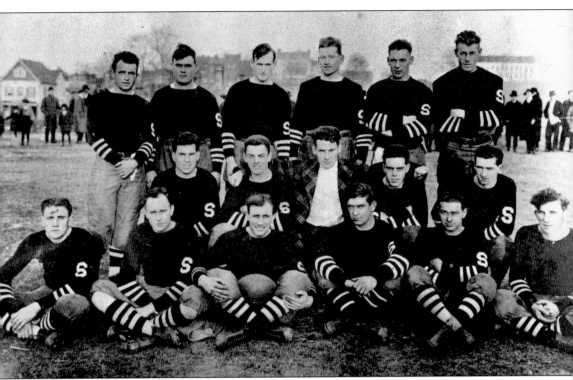

The Staten Island Stapeltons, a longtime island semiprofessional team, joined the National Football League in 1929. (Courtesy of the Staten Island Historical Society.)

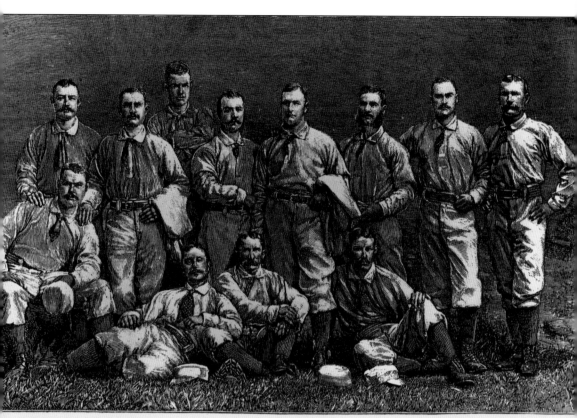

John H. Lynch, P. Charles Reipschlager, C. J. E. O'Neil, P. Edward Kennedy, L. F. J. C. Clapp, C. J. A. Doyle, P. Frank Haukinson, 3d B. Stephen Brady, R. F.
Thomas E. Mausell, C. F. Frank Larkin, 2d B. John Nelson, S. S. John Reilly, 1st B.

THE METROPOLITAN BASEBALL NINE

There were several Irish players among the Metropolitan Baseball Nine. From left to right are (first row) Thomas Mausell, center field; Frank Larkin, second base; John Nelson, shortstop; and John Reilly, first base; (second row) John H. Lynch, pitcher; Charles Reipschlager, catcher; J. E. O'Neill, pitcher; Edward Kennedy, left field; J. C. Clapp, catcher; J. A. Doyle, pitcher; Frank Haukinsonk, third and first base; and Stephen Brady, right field. Erastus Wiman bought the team in hopes of promoting Staten Island. The team eventually was purchased by the Brooklyn Dodgers. (Courtesy of the Staten Island Historical Society.)

117

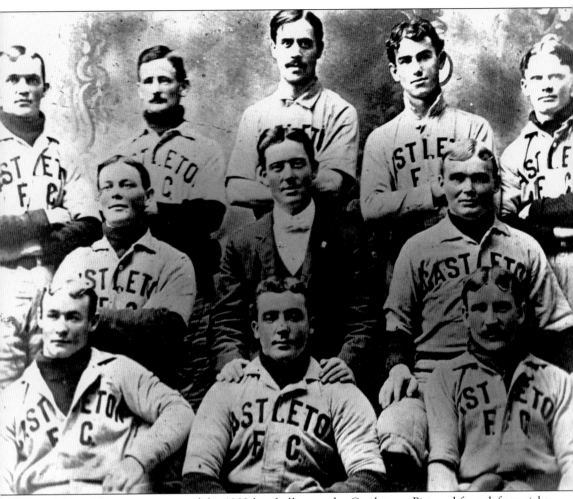

Matty McIntyre was part of the 1902 baseball team the Castletons. Pictured from left to right are (first row) Willie Deforest, Mort Kern, and Bernie Kelly; (second row) Larry Quinlan, Neil Driscoll, and Jim Graham; (third row) Willie Kelly, C. Lupton, Neil Collins, Matty McIntyre, and W. Langton. (Courtesy of the Staten Island Historical Society.)

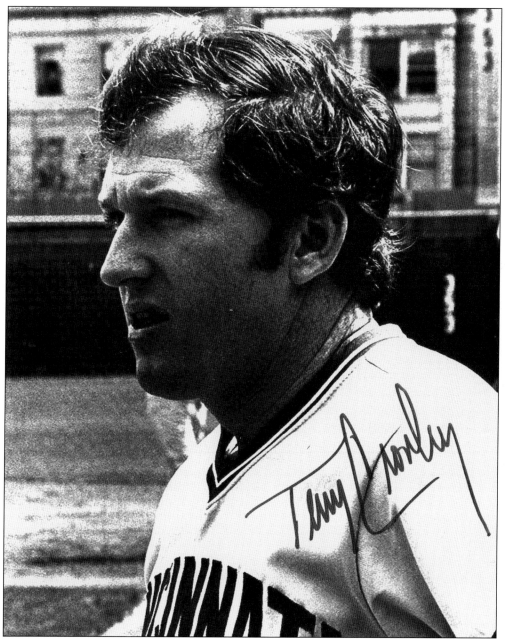

Baseball great Terrance (Terry) Crowley was known as "the King of Swing." Crowley was born on Staten Island in January 1948. Crowley had a 15-year major-league career and played mainly with the Baltimore Orioles. Crowley was one of the top pinch hitters in baseball and played in three World Series. He was later a batting coach for the Twins and the Orioles. (Author's collection.)

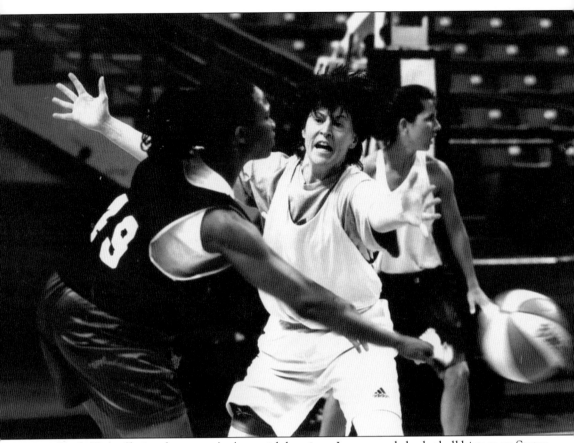

Sheila Tighe (facing the camera), along with her sister, Lynne, made basketball history on Staten Island. The sisters played for St. Peter's Girl's High School and are remembered still. Sheila later had an article in *Sports Illustrated* and went on to start her own production company in California. Lynne became athletic director for Villanova University. (Courtesy of Sheila Tighe.)

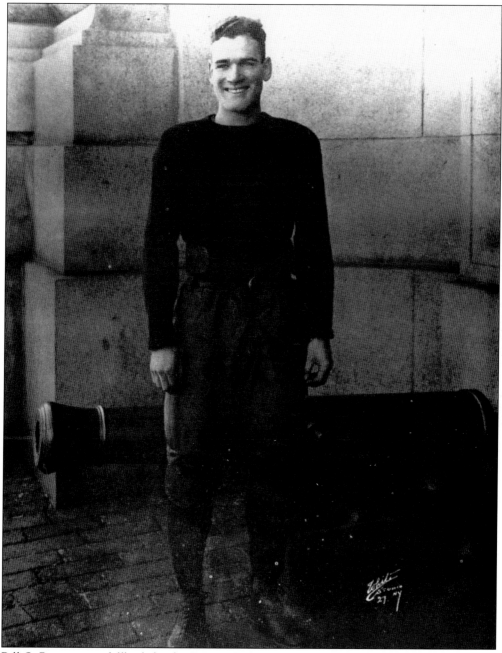

Bill O. Regan was a fullback for the Stapes. He later went on to become admiral in the navy in 1954. (Courtesy of the Staten Island Historical Society.)

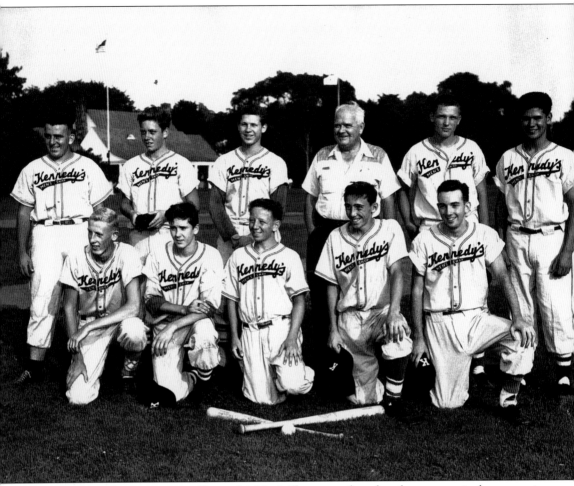

Like many business owners, Kennedy's Men's Shop contributed to the community by sponsoring baseball teams. In 1954, Bill Rogers of Bill's World of Sports coached another team to victory in the Little League World Series. (Courtesy of the Kennedy family.)

Seven

THE ARTS

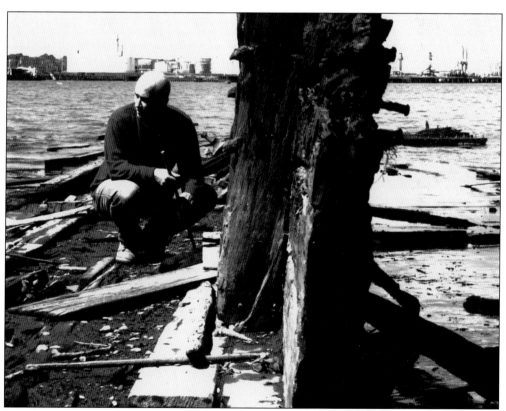

Well-known Staten Island artist Bill Murphy is the son of a New York City policeman. Murphy has taught art for more than 20 years at Wagner College. His work is shown in the Metropolitan Museum of Art. His subject matter has frequently included Staten Island locations. A particular focus for Murphy is the evolution of the Staten Island waterfront. He is seen here on Kreischerville Bridge. (Photograph by Bill Higgins.)

This view from the Bayonne Bridge offers a contemporary interpretation of the waterways and geography that surrounds the bridge. This watercolor, *From the Bayonne Bridge*, is a 60-by-56-inch painting done by Bill Murphy in 2007–2008. (Courtesy of Bill Murphy.)

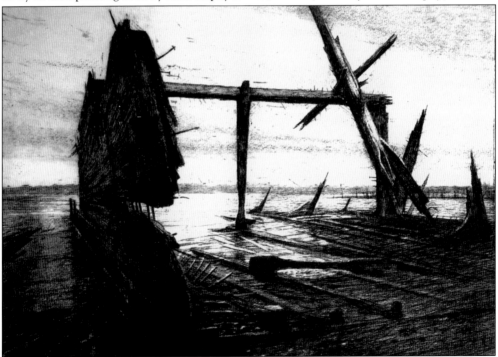

Staten Island Stonehenge, a 15-by-18-inch etching done in 2006 by Bill Murphy, is reminiscent of much of John Noble's portrayal of the Staten Island waterfront. Both Noble and Murphy have captured the past and continuing evolution of the waterfront, which plays an important role in the development of the island. (Courtesy of Bill Murphy.)

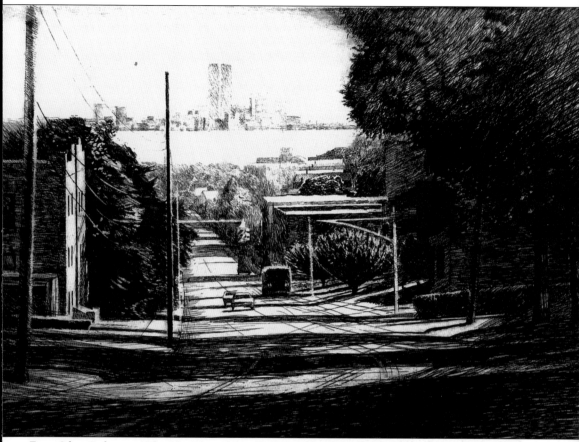

From Silver Lake, an 11-by-16-inch etching from 1999 by Bill Murphy, shows the incomparable view of the present Manhattan skyline from a crest on Victory Boulevard. This view, which is familiar to many commuters, captures the grandeur of the pre–September 11 skyline. (Courtesy of Bill Murphy.)

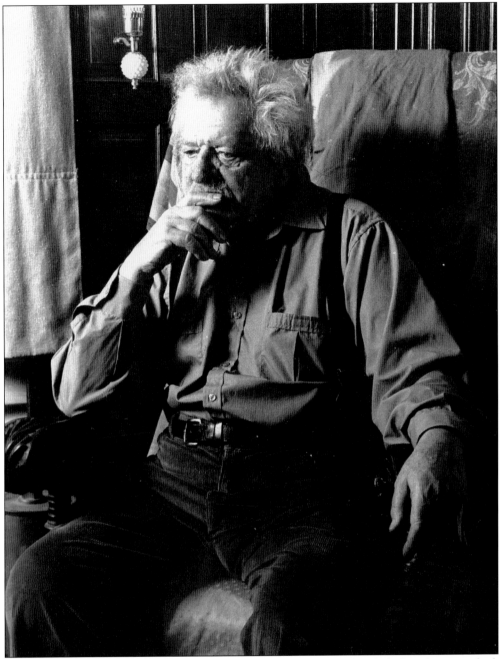

Staten Island artist John Noble was photographed by Bill Higgins shortly before the artist died. Higgins is well known for his photographs, which are particularly of historic subjects. (Courtesy of Bill Higgins.)

BIBLIOGRAPHY

Bayles, Richard M., ed. *History of Richmond County, Staten Island.* New York: L. E. Preston and Company, 1887

Clute, J. J. *Annals of Staten Island, From Its Discovery to the Present Time.* Interlaken, New York: Heart of the Lakes Publishing, 1986.

Dickenson, Richard, ed. *Holden's Staten Island: The History of Richmond County.* New York: Center for Migration Studies, 2002.

Halberstam, David. *The Coldest Winter: America and the Korean War.* New York: Hyperion, 2007.

Jackson, Kenneth T., ed. *The Encyclopedia of New York City.* New Haven, Connecticut: Yale University Press and the New York Historical Society, 1995.

Labarre, Suzanne. "Honoring the bones." *New York Times.* September 23, 2007.

Leng, Charles W. and William T. Davis. *Staten Island and Its People: A History 1609–1929.* New York: Lewis Historical Publishing, 1930.

Mahoney, Marguerite. "A History of the Mission of the Immaculate Virgin, Staten Island, 1870–1945." Unpublished master's thesis for Fordham University, 1945.

Sachs, Charles. *Made on Staten Island: Agriculture, Industry and Suburban Living in the City.* New York: Staten Island Historical Society, 1988.

Smith, Dorothy Valentine. *Staten Island: Gateway to New York.* New York: Chilton Book Company, 1970.

Steinmeyer, Henry G. *Staten Island: 1524–1898.* New York: Staten Island Historical Society, 1987.

ACROSS AMERICA, PEOPLE ARE DISCOVERING SOMETHING WONDERFUL. THEIR HERITAGE.

Arcadia Publishing is the leading local history publisher in the United States. With more than 3,000 titles in print and hundreds of new titles released every year, Arcadia has extensive specialized experience chronicling the history of communities and celebrating America's hidden stories, bringing to life the people, places, and events from the past. To discover the history of other communities across the nation, please visit:

www.arcadiapublishing.com

Customized search tools allow you to find regional history books about the town where you grew up, the cities where your friends and family live, the town where your parents met, or even that retirement spot you've been dreaming about.